Best
Practices
for
Middle
School
Classrooms

Other Books by Randi Stone

Best Practices for Elementary Classrooms: What Award-Winning Teachers Do, 2009

Best Practices for Teaching Reading: What Award-Winning Classroom Teachers Do, 2008

Best Practices for Teaching Social Studies: What Award-Winning Classroom Teachers Do, 2008

Best Practices for Teaching Writing: What Award-Winning Classroom Teachers Do, 2007

Best Practices for Teaching Mathematics: What Award-Winning Classroom Teachers Do, 2007

Best Practices for Teaching Science: What Award-Winning Classroom Teachers Do, 2007

Best Classroom Management Practices for Reaching All Learners: What Award-Winning Classroom Teachers Do, 2005

Best Teaching Practices for Reaching All Learners: What Award-Winning Classroom Teachers Do, 2004

What?! Another New Mandate? What Award-Winning Teachers Do When School Rules Change, 2002

Best Practices for High School Classrooms: What Award-Winning Secondary Teachers Do, 2001

Best Classroom Practices: What Award-Winning Elementary Teachers Do, 1999

New Ways to Teach Using Cable Television: A Step-by-Step Guide, 1997

Best Practices for Middle School Classrooms

What Award-Winning Teachers Do

RANDI STONE

Skyhorse Publishing

Library of Congress Cataloging-in-Publication Data is available on file.

Cover design by Michael Dubowe

Print ISBN: 978-1-63220-544-5
Ebook ISBN: 978-1-63220-961-0

Printed in the United States of America

Contents

Preface

My goal of helping teachers has remained the same for over a decade. I have introduced teachers from across the United States to the best practices in elementary schools and high schools, and now I bring to you best practices from middle schools across the nation. The success of *Best Classroom Practices: What Award-Winning Elementary Teachers Do* and the bestselling *Best Practices for High School Classrooms: What Award-Winning Secondary Teachers Do* has led to *Best Practices for Middle School Classrooms: What Award-Winning Teachers Do.* This book provides teachers with a new smorgasbord of information.

There is endless information out there, and it can take hours to find just what you are looking for. This book makes it easy. It is full of valuable lessons from outstanding teachers. These teachers are the ones shown in journals and magazines, the ones who win grants, fellowships, and contests. These are the Teachers of the Year, National Educator Award winners, recipients of the Milken Family Foundation award, ING Unsung Heroes, and the list continues. I wanted to know what makes them outstanding and what they are doing in their classrooms.

This book is the product of sharing at its best. There are four parts. Part I highlights classroom practices across the curriculum. Topics include classroom management, community involvement, technology in classrooms, and assessment. Some of the lessons in Part I are Internet Safety, Students Create Podcasts, and Short-Cycle Assessments. Part II focuses on science and math. Lessons include Creating a Thriving Prairie and The Hallway Crush: How Full Is Full? Part III addresses teaching language arts and social studies. Comparing Formal and Informal Language and Medieval Italy are just a couple of the topics

addressed. Part IV has a variety of lessons on music, art, and physical education, including Edible Color Wheels: A New Way to Introduce Color Theory and Chinese Zodiac: What Animal Are You?

I hope you enjoy each submission with the same enthusiasm and excitement that I did. *Best Practices for Middle School Classrooms: What Award-Winning Teachers Do* provides you with an inside view of education practices in the United States thanks to the tremendously giving educators who offer up their classroom-tested lessons in the pages that follow.

Acknowledgments

Skyhorse gratefully acknowledges the contributions of the following reviewers:

David Callaway
Eighth-Grade Language Arts Teacher
Rocky Heights Middle School
Highlands Ranch, Colorado

David Freitas
Professor, School of Education
Indiana University South Bend
Granger, Indiana

Evan Lefsky, PhD
Executive Director of Just Read, Florida!
Tallahassee, Florida

Diane Smith
School Counselor
Smethport Area School District
Smethport, Pennsylvania

About the Author

 Randi Stone is a graduate of Clark University, Boston University, and Salem State College. She completed her doctorate in education at the University of Massachusetts, Lowell. She is the author of 13 books, including her series *Best Practices for Teaching Reading: What Award-Winning Teachers Do; Best Practices for Teaching Writing: What Award-Winning Teachers Do;* *Best Practices for Teaching Social Studies: What Award-Winning Teachers Do; Best Practices for Teaching Mathematics: What Award-Winning Teachers Do;* and *Best Practices for Teaching Science: What Award-Winning Teachers Do.* She lives with her teenage daughter, Blair, in Keene, New Hampshire.

About the Contributors

Chris Anderson, Technology Education Teacher, Gateway Regional School District

E-mail: canderson@gatewayshs.com

Number of Years Teaching: 7

Awards: New Jersey Technology Education Program Excellence Award, 2008; Wawa and NBC 10's Environmental Community Service Award, 2008; Martinson Innovative New Jersey Technology Education Teacher of the Year, 2007

Dale Baumwoll, Sixth-Grade Social Studies Teacher, Randolph Middle School

E-mail: dbaumwoll@rtnj.org

Number of Years Teaching: 15

Awards: New Jersey History Teacher of the Year, 2007; Morris County Teacher Recognition Award, 2005–2006

Thomas J. Bennett, Sixth-Grade Science Teacher, NorthWood Middle School

E-mail: tbennett@wanee.org

Number of Years Teaching: 16

Awards: ING Unsung Heroes Award, 2008; Wawasee Academic Hall of Fame Outstanding Teacher Recognition, 1998–2000, 2002, 2003; Dekko Foundation Grant Recipient

Spencer Bolejack, Eighth-Grade Social Studies Teacher, Cane Creek Middle School

E-mail: spencer.bolejack@bcsemail.org

Number of Years Teaching: 14

Awards: Veterans of Foreign Wars Citizenship in Education Award: Local, Regional, and State Levels, North Carolina, 2008; Asheville *Citizen Times* Hometown Hero Award, 2003

Tony Carmichael, Eighth-Grade Science Teacher, West Oak Middle School

E-mail: tcarmichael@d76.lake.k12.il.us

Number of Years Teaching: 9

Awards: ING Unsung Heroes Award, 2007; National Wildlife Federation, Certified Wildlife Habitat, "Courtyard Turtle Project," 2007–2008

Sherry Crofut, Middle School Teacher, North Middle School

E-mail: Sherry.Crofut@k12.sd.us

Number of Years Teaching: 12

Awards: Black Hills State University 125 Accomplished Alumni, 2008; Milken Family Foundation National Educator Award, 2007; Office Max Make a Day Better Award, 2007

Sarah L. Crose, Math Teacher, Dawes Middle School

E-mail: scrose@lps.org

Number of Years Teaching: 15

Awards: ING Unsung Heroes Award, 2008; Nebraska Association for the Gifted Scholarship Award, 2005; Myrtle Clark Outstanding Math Teacher

Amy K. Dean, Art Teacher, Fort Mill Middle School

E-mail: deana@fort-mill.k12.sc.us

Number of Years Teaching: 10

Awards: ING Unsung Heroes Award, 2008; Japan Fulbright Memorial Fund Teachers Scholar, 2007; National Board Certified Teacher (NBCT), 2006

Alicia Deel, Special Education Teacher, Grundy High School
E-mail: adeel@buc.k12.va.us

Number of Years Teaching: 10
Awards: National Association of Special Education Teachers'
Outstanding Special Education Teacher Award, 2008; Who's
Who Among High School Teachers, 2007; American Legion
Teacher of the Year, 2006

Kathleen F. Engle, Physical Education Teacher, Newcastle Middle School
E-mail: englek@weston1.k12.wy.us

Number of Years Teaching: 27
Awards: National Teachers Hall of Fame, 2008; Carol M. White
Progress for Physical Education (PEP) Grant, 2002; Black
Hills State University Excellence in Education Award,
2000; Black Hills State University 125 Accomplished
Alumni, 2000

Donald Fought, Sixth-Grade Language Arts and Social Studies
Teacher, Southeast Middle School
E-mail: dfought@wsfcs.k12.nc.us

Number of Years Teaching: 8
Awards: Time Warner Cable National Teacher Award, 2008;
U.S. Department of Education American Stars of Teaching,
2007; National Team of the Year, National Middle School
Association, 2007

Bonnie Garrett, Seventh- and Eighth-Grade Science Teacher, Edward
H. White Middle School
E-mail: bgarrett@hsv.k12.al.us or bggarrett1@comcast.net

Number of Years Teaching: 7
Awards: Milken Family Foundation National Educator Award, 2007;
Edward H. White Middle School Teacher of the Year,
2005–2006, 2007–2008

Elizabeth Rees Gilbert, Sixth- through Eighth-Grade Teacher, Swan Meadow School
> E-mail: egilbert@ga.k12.md.us

Number of Years Teaching: 16
Awards: Garrett County Teacher of the Year, 2002–2003

Rebekah Hammack, Seventh-Grade Science Teacher, Stillwater Middle School
> E-mail: bhammack@stillwater.k12.ok.us

Number of Years Teaching: 3
Awards: Maitland P. Simmons Memorial Award for New Teachers, 2008

Gayle Gruber Hegerich, MA, Fine Arts Teacher, Lake Riviera Middle School
> E-mail: gnealyt@aol.com

Number of Years Teaching: 7
Awards: Moss Foundation for Children's Education National Teacher Award, 2008; Art Educators of New Jersey Middle Division Middle Award, 2008; National Endowment for the Humanities Grant, 2008; Governor's Award, 2009

Steven M. Jacobs, Eighth-Grade Middle School Earth Science Teacher (formerly Social Studies Teacher), Dundee Middle School
> E-mail: sjacobs@dundee.k12.mi.us

Number of Years Teaching: 6
Awards: ING Unsung Heroes Award, 2008; Walter P. Chrysler Award, "Closing the Technology Gap in Education," 2008; Lucy Simmons Technology Award, 2004

Susan Leeds, Science Curriculum Leader and Teacher, Howard Middle School
> E-mail: susan.leeds@ocps.net

Number of Years Teaching: 18

Awards: U.S. Department of Education American Stars of Teaching, 2008; PRISM Award (Promoting Regional Excellence in Science and Math), 2008; Teacher of the Year, Howard Middle School, 2006; Gustav Ohaus Award, Middle School, 2003

Judy Lindauer, Sixth-Grade Teacher, Nancy Hanks Elementary
 E-mail: jlindauer@nspencer.org

Number of Years Teaching: 15

Awards: National Education Association (NEA) Innovation Grant, 2006

Amy Maxey, Math Teacher, West Forsyth High School
 E-mail: amaxey@wsfcs.k12.nc.us

Number of Years Teaching: 14

Awards: U.S. Department of Education American Stars of Teaching, 2008; National Board Certification in AYA Mathematics, 2008; Winston-Salem Forsyth County Teacher of the Year, 2008

Michalle McCallister, Science Teacher, Alamo Heights Junior School
 E-mail: mmccallister@ahisd.net

Number of Years Teaching: 4

Awards: Maitland P. Simmons Memorial Award for New Teachers, 2007 and 2008

Judy McEntegart, Sixth-Grade Language Arts Teacher, Walsh Middle School
 E-mail: jmcenteg@framingham.k12.ma.us or judy5mc@yahoo.com

Number of Years Teaching: 25

Awards: Veterans of Foreign Wars Middle School Teacher of the Year, Massachusetts, 2008; You Are Special Award, Walsh Middle School, Framingham, 2004; Who's Who Among America's Teachers, 2002

Eric Melnyczenko, Seventh- and Eighth-Grade Math Teacher, Columbia Central School
 E-mail: emelnyczenko@sd194.org

Number of Years Teaching: 2
Awards: ING Unsung Heroes Award, 2008; Spectacular Teacher Award, Seton Academy, 2007

Denese Odegaard, String Specialist
 E-mail: denese@cableone.net

Number of years teaching: 25
Awards: American String Teachers Association (ASTA) Citation for Leadership and Merit, 2006 and 2008; Lois Bailey Glenn Award for Teaching Excellence from the National Music Foundation, 2006; North Dakota String Teacher of the Year, 2005

Julie M. Pepperman, Eighth-Grade Science Teacher, Bearden Middle School
 E-mail: peppermanj@k12tn.net

Number of Years Teaching: 24
Awards: Presidential Award for Excellence in Mathematics and Science Teaching (PAEMST), 2007

Brian C. Querry, Music Teacher, WBUC-TV Productions Adviser, Charles A. Huston Middle School
 E-mail: bquerry@wiu.k12.pa.us

Number of Years Teaching: 11
Awards: Pennsylvania Keystone Technology Integrator, 2008; Westmoreland Intermediate Unit Technology Expo, Presenter, 2008; National Education Association (NEA) Innovations Grant Recipient, 2006

Truman M. Savery, Band Director, Fifth Grade through Twelfth Grade, Hot Springs School
 E-mail: truman.savery@k12.sd.us

Number of Years Teaching: 7
Awards: ING Unsung Heroes Award, 2008

Tammie Schrader, Seventh-Grade Science Teacher, Cheney Middle School
 E-mail: tschrader@cheneysd.org

Number of Years Teaching: 9
Awards: Department of Education Fellowship, 2008; ING Unsung Heroes Award, 2007; Outstanding Earth Science Teacher of the Pacific Northwest, 2002

Samantha Schwasinger, Eighth-Grade English Teacher, Goodrich Middle School
 E-mail: smccray@lps.org

Number of Years Teaching: 5
Awards: Time Warner Cable Spotlight on Education National Award, 2006

Rebecca Stallings, Eighth-Grade English Teacher and Pre-Advanced Placement English Teacher, Homewood Middle School
 E-mail: rstallings@homewood.k12.al.us

Number of Years Teaching: 22
Awards: Alabama Farmer's Association (ALFA), Teacher of the Month, 2008; *USA Today*'s All-USA Teacher Team, Honorable Mention, 2007; National Board Certification in Early Adolescence/English Language Arts, 2001.

Amy Stump, Eighth-Grade Science Teacher, Toltec Middle School
 E-mail: astump@toltec.k12.az.us

Number of Years Teaching: 1
Awards: Arizona New Science Teacher of the Year, Arizona Science Teacher Association, 2008

Erin Sweeney, Health and Physical Education Teacher, Gainesville Middle School

E-mail: sweeneen@pwcs.edu

Number of Years Teaching: 3

Awards: National Education Association (NEA) Learning and Leadership Grant, 2008

Genia Webb, Seventh-Grade Math Teacher and Educational Consultant, Lexington Middle School

E-mail: gwebb@lexington1.net

Number of Years Teaching: 8

Awards: Milken Family Foundation National Educator Award, 2007; South Carolina Middle School Association, Middle School Magic Award, 2006

Lisa Wood, Kindergarten through Sixth-Grade Math Coach, Gibbs Albright Elementary

E-mail: lwood@newport.k12.ar.us

Number of Years Teaching: 18

Awards: Presidential Award for Excellence in Mathematics and Science Teaching (PAEMST), 2006; Mathematical Association of America, Arkansas Teacher of the Year, 2006; Who's Who Among America's Teachers, 2000, 2006

Darrell Yater, Instructional Specialist, Northwest Local School District; Adjunct Faculty, Xavier University, Northwest Local School District

E-mail: yateda@nwlsd.org or djyater@aol.com

Number of Years Teaching: 13

Awards: Outstanding Regional Educator Award, Southwest Region, Ohio Middle School Association, 2008; Milken Family Foundation National Educator Award, 2007; Hamilton County Educational Service Center Celebrate Excellence Award, 2007

PART I

Classroom Practices Across the Curriculum

Classroom Management and Community Involvement

Overview, Chapters 1–5

1. **Chris Anderson**, a technology education teacher from Woodbury Heights, New Jersey, shares how to stay in control of your class at all times. From the all-important first phone call home to the many subtle ways of preventing disruptions, Chris encourages us to get to know our students and form bonds of mutual respect.

2. **Amy Stump**, an eighth-grade science teacher from Eloy, Arizona, takes a new approach to classroom management and encourages students to monitor each other's behavior. Students form groups and write their own behavioral and academic performance expectations. Kids take ownership of their work, and Amy enjoys a class that understands the reasons behind rule making.

3. **Julie M. Pepperman**, an eighth-grade science teacher and a parent herself from Knoxville, Tennessee, sees that as children grow through the educational system, parents are often alienated from the schools. Julie knows that only calling parents after a child misbehaves is like "asking for help to extinguish a fire after the building burned down." That's why she gets parents involved early and often.

4. **Truman M. Savery,** a band director for fifth through twelfth grade from South Dakota, encourages his students to think about ways they can give back to the community as a band. One year, the band raised money to send a teacher to Boston so he could run in the Boston Marathon.

5. **Judy McEntegart,** a sixth-grade language arts teacher from Framingham, Massachusetts, invites local veterans to school to teach her students about Veterans Day. This day is not about the glory of war; rather, it is a way to involve the community in her class's education and to teach students about what ordinary men and women can do to protect the world and preserve peace.

1. The Process of Effective Classroom Management

Chris Anderson
Woodbury Heights, New Jersey

Recommended Level: Grades 6–8

Overall Objective: Teachers learn skills to effectively manage their class, both by preventing disruptions and by handling problems when they arise.

I loved when Mr. Longshaw gave me a hard time in high school. I was a typical smart-mouth student thinking I knew better than everyone else. But his attention, both negative and positive, was important to me and, looking back, was one of the reasons he was my favorite teacher. It may even be one of the reasons I am a teacher today. It comes down to something I didn't understand at the time but now see as methods of effective classroom management. These three simple words *effective classroom management* have so much meaning to many people. Both experienced and new teachers have ideas of how to successfully manage their students in a classroom setting.

Recently, I polled several student teachers I work with at a local college and asked them what classroom management meant for them. Most zeroed in on the idea that teachers need to know how to keep

students on task. However, there is much more to managing a classroom than most new teachers realize. Effective management in the classroom, as in business, involves being proactive, asserting ownership of one's classroom, and most important, coming to understand the very students you hope to manage. We must learn to stop looking at classroom management as a skill but, rather, as a process, one that we must engage in every day we stand in front of a classroom of students.

In that same survey, participants expressed hope to learn how to become "fast on their feet." Simply translated, this means they believed that, with time, they would one day develop a bulletproof list of scripted responses that could be thrown out at students when presented with almost any situation. As much as it is comforting to all of us who stand, day in and day out, in front of a classroom to believe that this magical list will one day appear, it is simply not true. Managing students in a classroom is about more than just reacting to the occasional crisis or behavioral problem. It is about being proactive and finding assertive solutions to problems that haven't even arisen yet, beginning even before day one.

So we begin with a technique that even the best of teachers feels reluctant to implement, that is, calling home. It can be uncomfortable and even frustrating, but this is one of the most effective ways to be a proactive classroom manager. Do not just wait until a student gets in trouble to call home, either. You should do it before the first day. If you begin your rapport with students and parents before class has even begun, it will change the entire dynamic of your classroom for the rest of the year. When students walk into class knowing you have already talked to their parents, they will recognize that you have a commitment above and beyond basic obligation. You have already spoken to (or at least left a message for) their parents; students will recognize that you will most likely have no problem continuing that relationship—particularly in regard to their behavior.

You cannot disappoint that expectation. Talking to parents can no longer be seen as a last-resort method for dealing with an unmanageable student but must be viewed as a continued dialogue. That means, do not call home only when there is trouble, but remember to call home when there is an accomplishment. For example, Mrs. Smith's son is a good student and never creates a problem for me. He's also not

the best at anything in particular, so in terms of teacher attention, neither he nor his mother receives frequent feedback from teachers. A call to work to convey something nice about her son provides the opportunity to brag to friends and could just make her day. You won't believe how many times I have phoned a parent after school or during their lunch break to report their child's successes. Some have even cried while on the line with me. Students, even the good ones, are so used to falling between the cracks—even when they accomplish something great—that sometimes the only way they can get noticed is through misbehavior or failing grades. Yet when a teacher takes time to share something incredible, all of a sudden it makes doing the "right things" seem that much more appealing.

This idea only begins to scratch the surface of the positives and negatives of behavior reinforcement. For instance, if you are having a bad day with a student (and it happens to even the best of educators), there is no shame in talking with the student at some point later in the day about your expectations. In addition, if you put a student down in front of the class or humiliate an individual in front of peers, it is crucial that you find a way to apologize or build this person up again while in front of the class—a one-on-one apology out in the hall will not make a public mistake right again. This not only helps to raise their confidence but also shows that you can be a fair and reasonable person. Treating a student with respect will never hurt your control over a classroom.

However, showing respect is not the same as backing down. Part of being an effective manager, an effective leader, and most important, an effective teacher is being, for lack of a better term, the alpha dog. The classroom is your world. If you show ownership of that world, your students will understand that, too. This is especially true for new teachers coming into a classroom. Take that room you are given and prove that it is now your own. Rearranging furniture, decorating to fit your tastes, and changing it to however suits you will show your new class that you are not simply a new teacher in an old teacher's room but that you are the ruler of this new world they have entered. Even subtly setting this tone will alter how your students react and behave in this new and unfamiliar classroom, your classroom. Of course, this new room should also be accompanied by a confident, knowledgeable classroom leader.

I have always believed evangelists and comedians understand stage presence. Students, as a whole, are some of the most intuitive people a person will ever face. They can decipher moods of their teachers and even their insecurities. This is why a strong classroom presence is so important. Never let them see you sweat. It is a cliché, but it's true. If you allow yourself to resort to sarcasm or to be baited into arguing, you will show them you have lost control of your world. Having ownership of this world that you created also means you cannot hand power over to an outsider. The minute you send a student out of class or down to an administrator, you show students you are not capable of managing your own classroom, and that is a weakness that will be exploited.

An alternative to succumbing to those classic classroom traps is to wield your authority in more subtle ways. Make eye contact with a student who begins to act out. If that isn't enough, stand by their desk; and if that doesn't work, place your hand on their desk as you continue with your lesson. Usually, the close proximity of an instructor will be enough to warn them against further transgressions. If they continue, do not be afraid to warn them that their seat will be moved. Of course, the next step after issuing the warning should be to move their seat, because students can see empty threats and will not hesitate to scoff at your authority if such threats prove fruitless.

Ultimatums are strictly your last resort. There are better ways to reach a student than a "this or that" threat. Kids, even the toughest cases, actually want to do the right thing. The most challenging students need the most attention. Lavish them with attention. The greatest thing you can do for challenging students is to give them a job. Having a role within the classroom increases their level of responsibility and makes them feel they have a place in your classroom. It is easier to label kids as problems rather than take the time to actually get to know them and help them.

As educators and mentors, we must think of struggling students not as problems, nothing more than annoyances to be passed over, but as challenges presented to us. They are there to make us earn our pay. You must strive to reach these kids not only in the classroom but on the playing fields or in the parking lot. Become more than a teacher they see for 40 minutes a day. Become an adviser, a coach, or maybe just a fan. Volunteer to start a club or coach a sport, or go to home games and

show your students you are committed. Students can be entirely different outside a classroom environment, and if you meet them in other places, then maybe your relationship will improve.

One technique I use in the classroom is the cultivation of "social capital." I reinforce positive behaviors with a type of figurative currency that students can spend. For example, the first two students who complete their warm-up (or anticipatory set), might have the option to pick the radio station we listen to during an activity. Another example would be to allow students to have control over more of the social decisions. This could include where they sit, when they can leave to use the lavatory, or any other terms and conditions within the classroom culture or environment that might otherwise be my call exclusively.

Above all, we must remember that students are people too, and they are not adults. Kids have a much harder time placing themselves in the shoes of others, and as a result, their empathy for their peers and their instructors seems limited. It is not. Second, the best thing about kids is that each day is a brand new day, a clean slate. As adults we often forget the true ability of adolescents to make a fresh start. For a teacher, that means every day is a new day to make a difference and another day to prove how effective our classroom-management skills truly are.

2. Developing Collaboration With Peers

Amy Stump
Eloy, Arizona

Recommended Level: Grades 6–8

Overall Objective: Create a classroom environment fostering positive collaboration among students. Students will develop norms and roles that are used throughout the year during group activities to develop positive collaboration with peers.

Standards Met (Arizona):

Workplace Skills: (4) Students work individually and collaboratively within team settings to accomplish objectives.

Materials Needed:

- Paper and pencils
- Blindfolds (strips of fabric work well)*
- Peanut butter and jelly

- Bread
- Butter knives
- Plates

*optional

Engagement

Divide students into groups of three or four. Start this lesson with an example focusing on the importance of working together to solve a problem or accomplish a task. One student from each group puts on the blindfold. The peanut butter, jelly, bread, plate, and butter knife are placed in front of the student. The remaining members of the group take turns telling the blindfolded student what to do to make a PB and J sandwich and divide it for each of them. The blindfolded students can only do what their teammates tell them. You could do this without the blindfold, but the blindfold makes it more interesting. Allow time for the students to eat the fruits of their accomplishment (the sandwiches). They work as a team to clean their tables and put away the supplies. Conclude this part of the lesson with a group discussion about what went well and not so well when they built the sandwich. I list the positives and negatives on the board.

Team Expectations

Write the following instructions on the board for students:

Individually, write on a separate piece of paper. What are your expectations for your team this school year? List three expectations. List one reason for each expectation.

I explain what the word *expectation* means, what to expect from yourself and your team members during group activities. After about five minutes, students rejoin their teams. Together, they discuss their individual expectations and pick the three most important expectations, referring to the positive and negative PB and J outcomes. All team members must agree. Then, write the Team Expectations template on the board; instruct the students to copy the template and write their team expectations in the front of their notebooks. All students are required to sign each other's notebooks.

Team Expectations

1. _____

2. _____

3. _____

We agree to the expectations listed above:

X _____

X _____

X _____

X _____

This process takes about five minutes. Explain that during the year, if group members are not living by expectations, other team members should remind them of their commitment. Periodically throughout the year, team members rate themselves and their teammates on how well they have adhered to team expectations. I usually have teams do this four to five times throughout the year after a group activity.

Team Roles

The last portion of the lesson establishes roles within the teams of students: manager, inquisitor, record keeper, and material handler. These are not static, and role assignments can change if students agree. Students, in their teams, discuss the strengths of their team members. For example, one student may excel at organization while another's strength may be to write clearly. Allow three minutes for group discussion, and then tell the students to select who will fill which role and to write the roles of team members in their note-books. I print the roles (you can fit four sets of roles to one piece of paper) and have students tape the roles into their notebooks. This enables students to refer back to the responsibilities of each role, and if they want to switch roles later, they have the information to make adjustments within their team.

Manager. Fill in for team members who are absent. Make sure all team members participate in the activity. Help team members with their roles.

Inquisitor. Ask relevant questions: "What do we know about the issue or problem?" "Do we need to know something else?" and "If we do, how are we going to get the information?"

Record Keeper. Write down information and data generated during the group activity and share with the team.

Material Handler. Make sure all materials are at the table, set up materials, and put them away at the end of the activity.

I conclude the lesson by telling the students that all members must participate in group activities. "It's not my role" should never be an excuse for doing nothing. Helping team members is encouraged and expected. After the next group activity, I have students rate themselves and their teammates according to the expectations written during this activity (see the sample rating sheet).

Your Name: _____ Date: _____

Instructions: Rate yourself and your teammates for each team expectation during today's activity. Ratings run from 1 through 5, with 1 meaning *did not meet* the expectation and 5 meaning *fully met* the expectation.

Team Expectation	Name:	Name:	Name:	Name:
1.	Rating:	Rating:	Rating:	Rating:
2.	Rating:	Rating:	Rating:	Rating:
3.	Rating:	Rating:	Rating:	Rating:

Written goals can then be set for teams who are not meeting team expectations. These goals are set by the team and are assessed at the end of each group activity. As soon as a goal is met, a new one is set until all teams are meeting expectations.

HelpfulTips

- I find it helpful to have supplies for the engagement activity at tables on trays. This allows the classroom to run smoothly and quickly since students don't need to leave their seats for supplies.
- Posting collaborative types of quotes and student roles throughout the classroom reminds students of their responsibilities. Roles could be illustrated throughout the classroom for quick reference for students who participate in special education or who are younger.

3. Successful Classroom-Management Strategies

Julie M. Pepperman
Knoxville, Tennessee

Recommended Level: Grades 6–8

Overall Objective: Prevent classroom misbehaviors by being fair and consistent and getting parents involved in their children's education *before* students act up.

When I began teaching, the only books I found on successful classroom management addressed elementary grades. I tried to adapt these strategies to the middle school level, but they weren't effective. Let's face it, most eighth-graders do not care whether their names appear on the green light or the yellow light. My eighth-graders were, and still are, smart enough to know just how far to push the limits before serious consequences are invoked. Think about it, these kids have been in school for as long as nine years (if they attended kindergarten) and have experienced many different teaching personalities, styles, and classroom-management techniques. They know the game.

In most cases, the students who want to obey and follow the rules, do and the ones who don't, won't. I needed something better, something that would appeal to these "almost high schoolers." I needed to develop a plan that fit my personality and teaching style. Through trial and error, I discovered that if a classroom-management plan doesn't fit how you teach or if it doesn't mesh with your personality, you won't stick with it. When you forget to implement your plan, even one time, you have lost all credibility with your middle school students.

I noticed the one thing that really seemed to bother my students was when they perceived something as being unfair. This notion of fairness, or lack thereof, led to many arguments among themselves and their teachers. The trick was realizing that my idea of fair and theirs is not the same. Eighth-graders' cognitive development is not quite at the stage where they can understand that fair and equal are not the same. As the adult in the room, I was fair to all my students, but from the students' perspective, I was not. For example, when I gave a student a chance to turn in work late with no consequences, other students found out and became disgruntled because it wasn't "fair." They didn't know that the night before, that student had a legitimate family emergency. In the interest of student privacy, I couldn't announce to the class, "Anne has permission to turn in her homework late for full credit because her dad had a heart attack." I could, however, set a policy with the class. I told them that sometimes, as a teacher, I would know things in their personal lives that might affect their schoolwork. They wouldn't want private matters shared with the rest of the students. I asked them to trust me to judge each situation individually.

Many students never had a teacher willing to judge them individually instead of applying a blanket policy. Of course, every year I have to prove my trustworthiness to a new group of students. But every year, it takes less time because I start to earn a reputation among the students. Yes, they actually talk about their teachers over the summer. They advise younger brothers, sisters, and friends on how to "handle" this teacher or that teacher. Students have tried to fake me out by claiming a family situation that doesn't exist, but those issues quickly come to light. After you establish your fairness with the students, then you need to move on to the second step, which is consistency.

Consistency, on the middle school level as well as in life, means doing what you say you are going to do when you say you are going to

do it. Period. Even the students you think are not paying any attention to you are keeping track of how often you follow through with your plans. This includes plans on discipline, classwork, class goals, and class rewards. Even without stating it, you have entered a contract with your students. You are saying, "I am the teacher, and I need to be in charge of the class. The class will be a safe place where all students can learn and express their ideas without ridicule. I will treat you fairly and with respect, and in return, you will do the same." The students are saying, "Even if we don't express it, we want to learn. We want to be treated with fairness and respect. We want school to be a place where we can grow and be successful." Every time you as the teacher and adult in the room fail to be consistent, whether it's something to do with academics or with classroom management, you are saying, "Even though I don't hold up my end of the bargain, I still expect you to." Middle school students will quickly see through this and come to view you as untrustworthy. Once that happens, limited learning will occur in the classroom.

I employed my strategy of fairness and consistency for a few years, and it was working, but I thought it could work better and there seemed to be something missing. I finally figured out what it was while chatting with a parent who I ran into at the grocery store. She said, "It was so much easier when Kevin was younger. I always knew what was going on at school because, for one, he would still talk to me about his day. Now he just says his day went 'fine.' The second reason I knew about his day was because the teacher would send home little notes and newsletters. We would even get an occasional phone call. I loved getting those calls telling me about something special he did."

We talked for a few minutes and said our goodbyes, but what she said stayed with me. I, too, used to receive positive phone calls, newsletters, and notes home about my daughter. I loved hearing about her day. I loved and valued this contact from the school, but I never thought of doing the same for middle school students' parents. After all, my students were big eighth-graders getting ready to go to high school and then on to college. Weren't they supposed to be learning how to be independent? Weren't parents supposed to be letting go, at least a little? I thought back and didn't remember receiving personalized school-to-home communication when I was an eighth-grader.

Through my professional development, I read studies where parents said they felt left out of their child's education by the time they reached middle school. They often expressed feeling uncomfortable volunteering at school or even contacting the teacher. This was especially true for parents whose own educational background is limited or who are non-English speakers or are economically disadvantaged.

All of a sudden it clicked. In the past, I called parents after a behavior issue, but by that time, the student was in trouble and received consequences. I realized it was like asking for help to extinguish a fire after the building burned down. What you're really doing here is damage control. I decided to try something different. The next year, I set a goal to contact all of my 135 students' parents. It wasn't easy. In one or two cases I used a translator, and some parents didn't have current contact information on file. It required a great deal of effort on my part, and it was worth every minute. By establishing a relationship with the parent before the child has any trouble or before I ask for volunteers, I create an atmosphere of teamwork. I show I care about my students and I am enthusiastic about my profession.

We all hear that successful education occurs when there is a partnership with the school, the student, and the parent. This maxim also holds true for classroom management. If I have a problem with a student's behavior, it is easier to get parental support if there is an existing relationship. Through initial communication, parents feel they know me a little and are willing to listen to my solutions to problems with an open mind. Does it work all the time? No. Are there always going to be parents who think you are singling out their child? Yes. However, the instances of this happening are fewer than before. In addition, positive phone calls can reduce the number of negative instances. Every now and then, pick up the phone or write a short note to parents about something unique, funny, or impressive their child did.

Parents love hearing it, and students love the positive attention they receive at home. This sends a message that you care. Parents want caring teachers who help their child succeed in school. The middle school years are a special and unique time in a child's life. One day they seem like adults, and the next they seem like little kids. Sometimes, they go back and forth several times in the same day! A teacher should take it in stride and react in a calm manner while being fair and consistent.

Students will notice and will respect you for it. Once you gain their respect and trust, you can teach them anything.

◪ 4. Taking Ownership

Truman M. Savery
Hot Springs, South Dakota

Recommended Level: Grades 6–8

Overall Objective: Each student learns how *taking ownership* goes beyond the classroom and into the community, beyond school pride, and also beyond inclusion of students with special needs.

Living in and teaching in a small school in Hot Springs, South Dakota, I have brought one mission to my students, and that is to take ownership of their music program. Ownership is very specific and goes beyond the classroom. Ownership for my students means learning to impact lives by recognizing and showing respect for the unique contributions and achievements of each individual. My community, whose population includes many veterans and individuals with special needs, presents numerous opportunities to learn this.

My inspiration as a teacher goes back to when I was a teenager. I remember a teacher asking me to help out with Special Olympics. At first, I wasn't sure whether I wanted to, but I decided to help. I watched parents, teachers, and other onlookers in tears of joy when their student crossed the finish line. You must understand the joy and unbelievable excitement they were experiencing, because these students' parents, teachers, and coaches were told these students with special needs would never achieve this type of triumph. The competitors cheered each other on, and it didn't matter whether they finished first or last; each competitor crossed with enthusiasm. I left that Special Olympics with a different perspective on life and accomplishments. At first, I thought I should go into special education, but I decided that my greatest desire was in music. In high school, I was an athlete and also a member of both band and choir. Before going into college, I remember thinking that perhaps one day I would start a band—one that embraces students with special needs.

After many years of teaching, I had a chance to pull out an old dream: There are many community members with special needs who have an interest in contributing to a band. The only way that this adventure was possible was for people in my community and my students to buy into this dream and dare to start something new. Out of this desire, a community band was born in a once-thriving music community. Citizens began writing about how exciting it was to have the band at veteran memorials, performances in parks, and at senior-living facilities. I honor veterans at every concert. The popularity of band is alive again.

Prior to my arrival, the community lost several directors in a short period of time. The repeated turnover of band directors created a problem: Students began skipping practice. My desire to serve this community and bring new life to the music program motivated me to be successful in my teaching career. Along the way, I discovered it is more important for students to become lifetime music lovers than for them to earn top scores at concerts. Students and the community taking ownership is the most important achievement. When visitors come, we hear how excited they are about our band program.

Many music students are involved in fundraisers to pay for trips and other adventures. Students must learn to give back to the community and do things for the sake of ownership. Giving back to the community greatly outweighs what the community could ever give back to the youth. One year at another school, my band sent a local teacher to the Boston Marathon. This was a huge achievement and impacted the community. The creativity to plan acts of kindness or other adventures must exist for students to give back to the community. For example, our school band and community band performed during a silent movie at our local theater.

Teachers should look for opportunities to impact their school and community: Take ownership, and teach your students to take ownership. There are many exciting adventures and joys to experience. Share your wealth of knowledge and commitment with others, and teach them to do the same. Impact lives, and when you feel like you have reached your plateau, realize that ownership goes further than the classroom. It is rewarding when the students finally understand the phrase *taking ownership*.

▓ 5. Parent Involvement: Heroes Among Us

Judy McEntegart
Framingham, Massachusetts

Recommended Level: Grade 6

Overall Objective: Students will know and appreciate the significance of Veterans Day. Students will have an opportunity to meet and listen to firsthand stories from a veteran and be able to ask questions to deepen their understanding of what it means to be a veteran. Students will appreciate the sacrifices made by ordinary men and women to keep this country free and safe, as well as to keep the world safe.

Standards Met (Massachusetts):

Language: (1) Discussion: Students will use agreed-upon rules for informal and formal discussions in small and large groups; (2) Questioning, Listening, and Contributing: Students will pose questions, listen to the ideas of others, and contribute their own information or ideas in group discussions or interviews to acquire new knowledge.

Reading and Literature: (7) Understanding a Text: Students will identify basic facts and main ideas in a text and use them as a basis for interpretation.

Materials Needed:

- Letters for parents and veterans organizations, interview questions
- Place for reception
- Light breakfast food
- Thank-you notes

In early November, my colleagues, parents, students, and I host a Veterans Appreciation Day. At open house in late September or early October, all sixth-grade teachers explain the program and invite parents to participate. We give them a letter again explaining the program. The letter includes a tear-off section that is to be returned to school. The

parents can indicate they will participate if they are veterans (or give names of veterans they know will be able to participate), contribute food for the light reception, or help host the light reception.

One sixth-grade student is assigned to each veteran. The student meets the veteran in the office and acts as an escort and guide. The two-hour program begins with a light reception; parents greet the veterans and serve the food. After the reception, the students escort the veterans to the appointed classrooms, and each veteran meets with a separate group of students. The student escort introduces the veteran to the members of the group, and the sharing begins. During the discussion time, the veteran shares stories prompted by questions from the students. After 20 minutes, the students change groups to hear another veteran. I have found that meeting with two veterans is enough for the students and the veterans. At the end of the discussions, the student escorts guide the veterans back to the reception room, where I thank them before they return home.

The preparation for this event has many facets. Not only do I invite veteran parents and relatives of our students but also veterans from the community. I go to the Veterans Council meeting during September with my invitations. The council is composed of representatives of all the veterans' groups in town. In turn, they bring the information to their groups. It is important to give an RSVP phone number and e-mail address. In October, my students read historical fiction novels based on World War II and the Vietnam War to gain some background knowl-edge. They keep a response novel while reading these books and attend three literature circle discussion groups in class.

I also prepare a lesson on the history of Veterans Day and, after presenting this information and discussing it, I assign my students an activity where they interview three adults about Veterans Day. I encourage them to find a veteran to interview. The questions for the adults are, "What is Veterans Day?" "What does Veterans Day mean to you?" and "What activities have you attended to celebrate Veterans Day?" The questions for the veteran are, "What military group did you serve with?" "Your rank?" "Where and when did you serve?" and "What does Veterans Day mean to you?" After the interview with the veteran, I tell students to invite them to our celebration. For the most part, this activity is interesting and exciting for the students. When it

is due, they share their findings with the class. Most are quite proud when reading about their relatives. Many are finding out information they never knew about their parents, grandparents, uncles, aunts, cousins, and neighbors. This begins a deeper understanding of what it means to be a veteran.

Just before the event, we brainstorm questions to ask our guests. We talk about appropriate questions and behavior. I remind them we are honoring these individuals for their sacrifices, bravery, and duty. The focus is to appreciate what these ordinary men and women did to protect the world and preserve peace. *It is not about the glory of war.* In addition, we talk about how a veteran may become emotional while relating a story. If this happens, I tell them to be respectful by being quiet to let the veteran regain composure. In this situation, the student host will then offer the veteran water and, when the time is right, ask what the veteran's favorite food was while serving. This has not happened often, but it helps to have a plan.

This activity has given an opportunity for family members of the sixth-grade students and veterans of the community to share their valuable stories. For the students, they experience firsthand primary-source information. Most important, students learn why they have no school on November 11 and see patriotism, bravery, duty, and sacrifice in person in veterans. After the celebration, the students write thank-you letters to the veterans they met and include specific information that they learned.

Using Technology in the Classroom

Overview, Chapters 6–10

6. **Sherry Crofut,** a teacher at North Middle School in Rapid City, South Dakota, believes that Internet safety is not about blocking a child's exposure to certain Web sites. Sherry explains that Internet safety begins and ends with parents taking responsibility for knowing how their children are using the Internet.

7. **Steven M. Jacobs,** a former eighth-grade social studies teacher from Dundee, Michigan, introduces his students to war and the art and business of filmmaking by asking them to film a stop-action animation of a battle or war using clay figures. Students write the script, create the sets and props, and edit the films. Once the film is created, Steven's students place ads in the local newspaper and host a community event where they show the films. When asked whether they can change the world, Steven's students say, "Yes we can!"

8. **Donald Fought,** a sixth-grade language arts and social studies teacher from Kernersville, North Carolina, has students make films every quarter to enhance their learning in social studies and language arts. Donald suggests a few topics that will have students so engaged in using technology that they won't even realize they're learning.

9. **Rebekah Hammack,** a seventh-grade science teacher in Stillwater, Oklahoma, asked her students, "If you could rewind the school year

and pick a unit to do over again, what would you pick?" About 90% of them opted for Rebekah's STEM (science, technology, engineering, and mathematics) Bridging Nations unit, where students use a real-life scenario as the basis for an interdisciplinary lesson on building bridges between developing countries.

10. **Brian C. Querry,** a music teacher at Charles A. Huston Middle School in Lower Burrell, Pennsylvania, lets students listen to their portable media players in class. In teams, Brian's class researches and creates podcasts on topics of their choosing. The finished product is something they can save on their personal player and share with their friends.

℞ 6. Internet Safety

Sherry Crofut
Rapid City, South Dakota

Recommended Level: Grades 6–8

Overall Objective: Students and parents learn to think critically about what Internet safety means.

Standards Met (South Dakota):

NCTE/IRA (National Council of Teachers of English and International Reading Association): English Language Arts (1) Students read a wide range of print and nonprint texts to build an understanding of texts, of themselves, and of the cultures of the United States and the world; to acquire new information; to respond to the needs and demands of society and the workplace; and for personal fulfillment. Among these texts are fiction and nonfiction, classic and contemporary works.[1]

ISTE (International Society for Technology in Education): (5) *Digital Citizenship:* Students understand human, cultural, and societal issues related to technology and practice legal and ethical behavior.[2]

A couple of years ago, we had a speaker visit to discuss Internet safety with our parents. I attended to be sure I was covering the same information with my students. I found that, as the evening progressed, the conversation focused on how parents could block their children from various Web sites. I stood up and firmly objected: Blocking is not the answer. I reminded parents that their children would simply go to a neighbor's house and do whatever they wanted on the computer; as parents, it is their job to teach their children how to access appropriate information and how to behave in an online world. I must have been firmer in asserting my beliefs than I realized because the next day our local paper called me to discuss my viewpoint on Internet safety. After a discussion with my principal, who is very supportive of my opinion, I agreed to be interviewed. As a result of the interest generated, our school staff set up a family night where we could teach parents about what is online. We focused primarily on social networking sites, such as MySpace, Facebook, and Bebo, where our children spend much of their time.

I was able to get our district's technology director to drop the firewalls for the evening, and I showed parents each of these sites through my own accounts. I showed them how easy it is to set up an account and told them that if their kids have an account in one of these sites, they should as well. I also told them that they should require their child to make them their online friend. Some of my parents were reluctant at first, believing that this might violate their children's privacy. I reminded them that the Internet isn't private and if their child is posting something inappropriate, they are the ones who should be teaching them differently. We then looked at a number of students' Web sites and saw some things that were rather alarming. My principal was there the evening we found one student had posted a personal cell phone number on the site. This led to more discussion and further communication.

Parents quickly found their own students' pages, and the best part was that they were going home to discuss the issue with their child. We helped parents set up accounts and see private pages, alerting them to the fact that the privacy settings really weren't that hard to get around. The next day during lunch, my principal told the students that she had been on a number of their Bebo pages and was rather disturbed by much of what she had seen. She had personal conversations with a few

and gave some students prizes for excellent pages. She told the ones with unacceptable pages, inappropriate for middle schoolers, that she would mail the printed pages home to their parents if they didn't make changes. There was a bit of grumbling from some students, but they realized that they weren't in trouble and we were looking out for the image they were portraying to the public. I did a follow-up class about how employers are starting to look at online pages for hiring purposes and students could miss job opportunities because of inappropriate information online. This opened a few eyes.

My students know I have pages on each of these sites, and I have innumerable requests for online friends every year. This always surprises me. I don't think I would have necessarily asked a teacher to be my "friend" when I was in middle school. I never seek students to be online friends, but I do accept them if they ask. I usually only check out the pages of my friends and continue to have those conversations with the students I am concerned about. I have never had a student refuse to change their page when I explain my concerns. Some list more information than is safe. One posted a picture standing right in front of his house with the house numbers visible over his shoulder, and he listed his town. One posted a beautiful picture of herself, but she was holding a large knife in a frightening way. I did tell her that the picture of *her* was lovely, but the knife was really not acceptable. She changed it that evening.

I know there are a number of districts that do not allow their teachers to have social networking pages and do not want them communicating with students this way. While I understand their caution, I am worried that if we don't take the initiative to communicate with our students about what they are posting, who will? We offer family nights every year, but we reach a fraction of the parents. If they don't understand these sites and teachers are not allowed to visit these sites, then children are out there teaching themselves and learning from their peers. This is not a good situation.

My students frequently message me with questions about assignments or field trips. Sometimes, they want to let me know about things that have happened in school that they are not comfortable talking to me about in school. We have a bullying problem that we are working on, and this gives my students one more avenue to find me. They also

pass on messages where they are bullied online. While this frequently spills into the school, we are able to take these to our liaison officer and let her handle these situations. I also have a number of former students who keep me posted on how they are doing through these sites.

My son is 24 and working for a major aerospace company. The employees all have Facebook pages and use them to communicate with their workgroups. These sites have taken on a life of their own, and I feel very strongly that kids need to have some guidance in using them. Educating parents so they are equipped to deal directly with their children is the best way to handle this, but until all parents are helping with this, we need to continue teaching our kids what is safe and appropriate.

Notes

1. *Standards for the English Language Arts,* by the International Reading Association and the National Council of Teachers of English, copyright 1996 by the International Reading Association and the National Council of Teachers of English. Reprinted with permission. http://www.ncte.org/standards

2. Copyright 2007 by the International Society for Technology in Education. http://www.iste.org/Content/NavigationMenu/NETS/ForStudents/2007Standards/NETS_for_Students_2007_Standards.pdf

▧ 7. Lights, Camera, Action!

Steven M. Jacobs
Dundee, Michigan

Recommended Level: Grades 6–8

Overall Objective: In this technology-focused social studies project, your students will learn about war, the costs of war, animated film production, and marketing a product to the public.

Standards Met (Michigan):

Social Studies and Technology: (H1.2) Historical Analysis and Interpretation; (H1.4) Historical Understanding; (P4) Citizen

Involvement; (E1.1) Individual, Business, and Government Choices; (E1.3) Prices, Supply, and Demand

Materials Needed:

- Digital cameras
- Software to create and edit movies
- Tripods
- Shoe boxes
- Modeling clay
- Construction paper

Three objectives will become clear to your students during the course of this activity. First, every student has the potential to love and understand the principles of economics and history when they are presented in an interactive way. Second, war is more than just battles; it has both positive and negative costs. Third, everyone has the potential to make a difference. The goal of this project is to teach not only about war but also about understanding, tolerance, and community involvement. Can I change the world? "Yes" is the answer you will hear from students in your social studies classes after this project. You should roll out the red carpet for this unique and innovative lesson that helps your students to understand war from American history, engage in community service, develop a working knowledge of economics, increase their technology literacy, focus cross-curricular writing, and build their knowledge of current events.

The project involves the use of advanced technology in the creation of a stop-action animated film. In differentiated learning communities, your students will create a film by writing scripts, making props, and taking digital pictures of their clay characters. The creation of the script will be the most challenging portion for your students. I recommend that you pick a structure for the play ahead of time. You could have the students make the movie cover one battle or even the entire war. I would advise you to give each group only one scene from the animated movie to write about. For multiple classes, it may take the creation of multiple movies rolled into one. However, creating a script that is coherent and tied together is the most important part. The clay characters can be made, or students can use plastic dolls. I suggest that you show the students a stop-action video from the Internet to give them a working understanding. Your students will need to make scene backgrounds out

of construction paper and then place them inside a shoe box (similar to a diorama).

After creating all of the script, scenes, and props, you're ready for the photography. The number of groups that you create will depend on how many digital cameras and tripods you can procure. It is extremely important that you explain to the students the importance of camera stability and limiting large movements of the characters. The more pictures you have the students take and the smaller the movements of the characters are, the better their film will turn out. After the students have taken their pictures, they will be ready for production using editing software. Your students will then add transitions, effects, titles, narration, and music to their portion of the movie. After completing their film, they will create DVDs, liner notes on what they have learned, and cases for sale.

Once the videos have been created, your students should hold a community movie night with all the glitz and glam of Hollywood. Leading up to the big event, your students will need to create promotional flyers, send e-mails, and post ads in the local newspaper. This will be the perfect time to discuss business marketing, product development, price points, profit margins, advertisement, and supply and demand. Then invite parents, community members, staff, and students to view the movie. Funds can be collected through admissions, concessions, and video sales. I recommend getting students involved in the community by collecting funds from this project and donating them to a military organization. In this, your class will have the opportunity to make war real and make connections between current events and the past. There are many excellent organizations around the nation for you and your class to team up with. You can donate to an organization such as the Injured Soldiers Foundation that helps to rehabilitate injured veterans and acclimate them into daily life.

Benefits to Students

This project will benefit every student in your class, those who participate in special education and those who are considered advanced learners. I suggest that you use differentiated learning communities and differentiated roles for completion. The roles should be given out based

on ability. The increased technology used in this lesson will benefit other teachers and classes at your district. It is not often that students are excited about history. They may exclaim, "Why do I need to know about old dead people?" Well, that question will be no more when it comes to your innovative project. The students see how the world works and learn their history at the same time. Students have always been excited to create, write, direct, and produce. This activity provides these opportunities with an economic, community, and historic twist.

8. Using Technology to Teach Language Arts and Social Studies

Donald Fought
Kernersville, North Carolina

Recommended Level: Grades 6–8

Overall Objective: Use video as a way to involve students in researching and presenting an issue.

Standards Met (National):

NCTE/IRA (National Council of Teachers of English and International Reading Association): English Language Arts (8) Students use a variety of technological and information resources (e.g., libraries, databases, computer networks, video) to gather and synthesize information and to create and communicate knowledge.[1]

Materials Needed:

- Video camera or cameras
- Editing software
- Access to computers for editing and production
- A way to show video productions when finished (projector with speakers is ideal)

I am a big fan of technology in my classroom. I teach sixth-grade language arts and social studies in a typical public middle school of more than 1,000 students. I teach two 2-hour blocks a day, one of which

is for students who are academically gifted and one for students in general education (many of whom are behind in academic standards). My room is equipped with a 50-inch plasma TV, a laptop computer, a document camera, and a SMART Board airlining tablet. I have access to digital cameras and a video camera and computer labs.

Creative Use of the Video Camera During Learning

I assign a video project to my students once a quarter. The project can be anything you dream up that fits a particular instructional need. I have used these assignments in the past: (1) What is culture? (2) What do good readers do to create comprehension? (3) Why study the five themes of geography? (4) What are the elements of literature, and how are they used to interpret text? and (5) Succeeding in school. I have also included more civic-oriented themes; for example, Should health care be free? and Should we be the defenders of democracy around the world? The point is for the assignment to be one that can be presented via video yet one that challenges students to use higher-order thinking skills and is relevant to their learning. I have students work in teams of three to four.

I generally budget from six to eight days to complete the work: two to three days to develop a storyboard, two days to film, one day to edit and produce final copy, and two days to view and present work. If you are doing this for the first time, budget extra time for training students in how to effectively plan, video record, and edit. Give each team the same project or vary the projects by team. Students research and plan their shoot, which often involves interviewing others (especially the civic-oriented assignments). They shoot their video. I then arrange computer time for students to edit their footage using software, where they create their final video (usually 5 to 7 minutes in length). We then share and discuss our presentations. (*Note:* C-Span sponsors an annual video competition on civic affairs, which I have used as a whole-class learning project. Refer to www.studentcam.org for more information.)

My personal objective with this video project is to provide my students with engaging activities where they learn through applying creative thinking, working in teams, and learning how to evaluate and synthesize information. I have found that when they use technology,

students often become so engaged in the activity that they forget they are learning.

Note

1. *Standards for the English Language Arts,* by the International Reading Association and the National Council of Teachers of English, copyright 1996 by the International Reading Association and the National Council of Teachers of English. Reprinted with permission. http://www.ncte.org/standards

9. Bridging Nations With Problem-Based Learning

Rebekah Hammack
Stillwater, Oklahoma

Recommended Level: Grade 7

Overall Objective: Introduce students to engineering and the relationship between science and technology, while providing them with experience taking measurements, graphing, and using the metric system.

Standards Met:

National Science Education Standards: Science as Inquiry. Abilities necessary to do scientific inquiry; Understandings about scientific inquiry. *Science and Technology.* Science and technology in society.[1]

Materials Needed:

- Toothpicks
- Paper clips
- Adhesive tape, glue
- Wooden craft sticks
- Drinking straws
- Copy paper
- String
- Aluminum foil
- Varying amounts of mass
- Metric ruler

When trying to choose an activity to write about for this book, I asked my students, "If you could rewind the school year and pick a unit to do over again, what would you pick?" About 90% of my students

chose the Bridging Nations unit, and I agree. Throughout the unit, my students—those with learning disabilities or emotional struggles, those who are considered gifted and talented, and those who are average performers—were all successfully learning side by side. Discipline issues were not a concern, because my students were actively engaged in the lessons. Students were learning and having fun.

Currently, there is a shortage of students who pursue careers in science, technology, engineering, and mathematics (STEM) fields. To address this issue, I went through my curriculum and looked for places where I could incorporate STEM activities into what I was already teaching. Like many middle school science teachers, I start the year by teaching the basics: the scientific method, graphing, and measurement and the metric system. I decided to develop a STEM activity that incorporated those basic science concepts and present it as a problem-based scenario. I collaborated with teachers from other subject areas to develop a project that can be used as either an interdisciplinary unit taught by a team of teachers or as a stand-alone science curriculum.

The first week of school, I introduced my students to two developing countries that had long been at war with each other, battling for control of the region's resources. After many years, the nations had reached a peaceful agreement and decided to share the region's wealth, but all of the bridges crossing the river between them were destroyed during the war. The students were members of an engineering team that was trying to win the contract to build a bridge that would allow for trade across the river. Students had to design, build, and test a prototype that would solve the problem.

First, I covered the steps of the scientific method and engineering-design process, and my students and I discussed the similarities and differences between scientists and engineers. Then, we discussed the metric system, including standard units and the tools used for different types of measurement. Students practiced metric conversions and making precise measurements. Next, I explained to my students that materials in that region of the world were limited, and I provided them with a list of available materials and the price associated with each (see Table 9.1). I also explained that, as with most things in the world, money was an important factor in their project and they would have a budget of $150. Other than material and budget limits, the only other requirement was for the bridge

Table 9.1 Cost and Packaging Size of Available Resources

Material	Price ($)
Toothpicks, 10 per bundle	30
Paper clips, 10 per bundle	30
Adhesive tape, 10-cm strip	8
Glue, teaspoon with cotton swab	6
Wooden craft sticks, 4 per bundle	40
Drinking straws, 10 per bundle	20
Copy paper, 1 sheet	3
String, 10-cm length	5
Aluminum foil, 8-cm width	3

to be a minimum of 15.5 cm long and a minimum of 4 cm wide. Students were given no other guidelines and were free to design the bridge any way they wanted.

Students worked in groups to brainstorm possible bridge designs. After choosing their design, they gathered their supplies and built. Students were responsible for counting out supplies, as well as measuring and cutting their supplies to the dimensions listed in Table 9.1. After building, students tested their bridges by adding varying amounts of mass to the bridge and measuring the distance that it sagged in the middle. After testing their original designs, students reflected on their results by answering the following questions:

- What was the maximum amount of mass that the bridge could hold before it failed?
- What happened to the bridge when it failed?
- Which parts of your bridge design worked well? Why do you think so?
- Which parts did not work well? How do you know?
- Can you think of anything you could do to make the bridge stronger?
- How will you know whether your bridge design is improved?

After reflecting on the original bridge designs, I took my students to the computer lab to research bridge structure and design online. I chose to have my students research after their original design because I did not want to stifle their creativity. I did not want them to merely copy a design they saw online; I wanted them to use their creativity to come up with their own design instead.

After students completed their online research, I asked them which was stronger, metal or wood, and why. We had a small class debate, during which most students supported metal because it was heavier and would not rot or mold. At that point, I gave my students a piece of metal (aluminum foil) and a piece of wood (paper) and had them test the strength of the materials by adding mass to the materials until they broke. They concluded that the paper was stronger, which led to a class discussion about not generalizing about materials.

Students took the information they gathered online and the results from their original design and used them to redesign their bridge. I gave students an additional $50 to use for rebuilding. After students built and tested their second design, we discussed how to organize their data in a graph, and I showed them how to make a double-line graph. Students graphed amount of sag (cm) versus mass (g) from both tests using an online graphing tool (see http://nces.ed.gov/nceskids/createagraph/default.aspx). Finally, students reflected over the entire project, discussing how their bridge design had improved and what they would do differently if they could start the unit again.

Pre- and posttest data show an increase of 52 percentage points in content knowledge for science standards A, E, and F. No, it's not a typo; the average on the posttest was 52 percentage points higher than the average score on the pretest. I think the large increase in student performance was directly linked to the high level of student engagement. My students became personally involved in the dilemma of the two nations. They really wanted to help solve the problem, and they even asked to create their own names for the countries. This personal interest in the success of the bridges kept students actively engaged and learning throughout the unit.

Problem-based units, such as Bridging Nations, are highly effective for teaching students and are a great way to incorporate

STEM into the classroom. They allow students to see the purpose of what they are doing in class and why it is important to their lives. Students become actively engaged, increasing learning and decreasing discipline problems. Best of all, most existing lesson plans can easily be converted to problem-based activities by creating a scenario for the unit. I can honestly say that students have "crossed over the bridge" to learning by physically experiencing their five senses and mentally solving problems through participating in this interesting unit.

Helpful Tips

- *Make the topic relevant to your students.* My students were engaged in the activities because they understood the relevance of what they were doing. If I had just told my students to build a bridge without giving them a purpose for doing so, my students would not have been as engaged. Each day of the unit, I referred to the scenario to keep it in the forefront of my students' thoughts. I also started each class period with a bell ringer consisting of two to three questions that allowed students to think about their experiences with technology. Examples of these questions are How many bridges do you cross on the way to school? and What would society be like without bridges? We discussed the answers to these questions before moving on to the day's activity. The discussions made the concepts we were studying relevant to my students and started students thinking about technology and how it impacts their lives. Problem solving is a wonderful learning tool when students are given the challenge. You will be surprised by how much student engagement increases just from presenting them with a real-world situation and problem to solve. The key is making sure it is relevant to *your* students.

(Continued)

(Continued)

■ *Get other teachers involved.* The real world is not divided into individual subject areas. Instead, different subjects intertwine throughout daily life. Keeping this in mind, doesn't it make sense to teach our students using an interdisciplinary approach? Bridging Nations was designed to be taught by a group of four teachers (science, math, language arts, and social studies). When using an interdisciplinary approach, the unit could be taught as follows:

Science: Focus on technological design, forces, and properties of materials.

Math: Focus on angles, graphing, and budgets.

Language arts: Focus on persuasive writing and creating a presentation to win the engineering contract.

Social studies: Focus on the question, What is a developing country? Possible topics include location, social structure, economy, and culture of different third-world civilizations.

Note

1. Reprinted with permission. http://www.nap.edu/openbook.php?record_id=4962 &page=105

℞ 10. Students Create Podcasts

Brian C. Querry
Lower Burrell, Pennsylvania

Recommended Level: Grade 8

Overall Objective: Students will compose an educational podcast on a selected topic, demonstrating appropriate research skills and use of related computer hardware and software.

Standards Met (Pennsylvania):

Science and Technology: (3.6.B) Technology Education, Information Technology; (3.7.C) Technological Devices, Computer

Operations; (3.7.D) Technological Devices, Computer Software; (3.7.E) Technological Devices, Computer Communication Systems

Materials Needed:

- Computer with projector (for demonstration)
- Computers with Internet access for student use
- Audio-recording software
- Online media player (such as iTunes)
- Web site or service for hosting podcasts
- Royalty-free music clips

In this unit, students will learn how to create a podcast using microphones and audio-recording software.

Students growing up in the 21st century are wired differently than students from even 10 years ago. Kids are immersed in technology almost all day long. I found that it was extremely important to introduce a technology to students that would be beneficial and innovative in their instruction. Over the past few years, I have noticed that almost every student owns a portable media player. When polled, these students said that they use their media players about two hours per day. I wanted to tap into this avenue and have students explore class content through this medium. So I began posting a series of recordings on my Web site that students could download, including lesson reviews, project summaries, and so forth. Upon finding these approaches successful, I wanted to see how effective it would be if students created podcasts to teach other students. Therefore, I built a unit around this idea when I rewrote my curriculum. The unit integrates creating a podcast with audio recording and editing. When I began designing this unit, I wondered what I could do to teach students about creating podcasts without needing expensive equipment and hours of training in using technology.

This unit allows students to learn about podcasting and how to create their own using inexpensive and free things they can even use at home. I start the unit by having a discussion on what students know about podcasting. Most of the time, I've found students are often misinformed as to exactly what podcasts are and how they differ from regular audio recordings, such as MP3 files. I ask students to do a Webquest and find three different examples of podcasts and how they are used. In this

search, students are usually able to hone their definition of a podcast. Next, we listen to some examples of podcasts and discuss how one can subscribe. Then, we begin the design process. I take students through designing and recording a podcast. The first step is to take an entire class period to show students how to research information, compile the information into a format appropriate for a podcast, record the speech, mix in music, and then save and publish their final audio file.

Before they can research information, students select working groups and a topic for their podcast. The topic must be something with which students can create an educational piece. As students research, they compile their information into a format appropriate for a podcast. The podcast is broken down into five sections: welcome, introduction, body of information, teaser for next broadcast, and the outro (or ending). Next, students are given instruction in basic use of audio-recording software. Learning to use this software is straightforward. Students have demonstrated that they can navigate through this technological environment very easily. While you can use most microphones with audio-recording software, I have a small supply of Alesis USB podcasting microphones that we use. The microphones were very inexpensive and have proven to be very good quality. So far, the only expenses we have in this unit (other than the computers being available) are the microphones.

Audio-recording software is free for download, and many Web sites include instructional videos that you can use as supplements to your instruction. Students can also use royalty-free music to enhance their podcasts. Once student groups have finished editing and save their final recordings, they upload them to a Web site. There are many free or inexpensive podcast hosting sites. Also, your school district may give you space to host these recordings. I created a link on my teacher Web site where students can access the uploaded podcasts using an online media player. Students finish the unit by going online and listening to each group's podcast. Each student evaluates the podcasts based on a set of criteria they help establish, including quality and effectiveness of the recording. This is also a great way to be the "cool" teacher.

With administrative approval, I permit students to download the podcasts groups have created onto their personal media players. Then, instead

of listening to the clips online while in class, they can listen on their portable media players in their seats. This involves less preparation for the teacher, and students get excited about the idea of being allowed to listen to their portable media players in class. Just be careful they are not listening to something they shouldn't be listening to. There are many options in this unit for differentiation. On one hand, I partner students in groups to foster a collaborative (mentor-mentee) relationship. Students who demonstrate "teacher" qualities then mentor the students who need extra assistance and help them develop skills. On another hand, I often find it interesting to offer groups who demonstrate readiness an additional challenge—to create a video podcast. I have several flip video cameras that students may use in place of the microphones. To use the flip cameras, students must be willing to demonstrate understanding of how to use the cameras and the appropriate software to do some basic editing on their video.

HelpfulTips

The unit will take some preparation time for it to work effectively. Different parts of this unit can also be taught independently of each other. Before teaching this unit, be sure you are comfortable using the equipment and the software yourself. Because this equipment is likely new to most of the students, there will no doubt be questions and problems that come up when students are working. Keep in mind that these kids are 13 and 14 years old and are often so eager to learn that they rush through things.

Also, think about Internet permission forms or waivers for students (especially if you are having them include their names in their podcasts) ahead of time. I occasionally have students who are not permitted to have their name or face appear online. For these students, I have them either select a fictitious name or have their group refrain from using names in their podcast.

(Continued)

(Continued)

In addition, there are parts of this unit you may need to adapt based on your available equipment and supplies. I have been fortunate enough to have access to our school's wireless laptop lab and have a set of 12 Alesis microphones for groups to use. If cost is an issue, you can easily acquire inexpensive microphones with decent quality. This also may affect how many groups you have or how your groups will record. If you only have a few microphones, you can create a supplemental activity while some groups are recording.

You have the option of having students work in groups or individually on this project. I have had several student groups use this project as a "launching pad" for their own podcast programs, with topics ranging from entertainment and music to commerce: One girl made a podcast for her mother's business. This unit can be applied to almost any subject area and is a really great way to have students use technology to enhance their learning. It would be very easy for me to have students type a report, give a speech, or even create a computer presentation. By having them compile their information in podcast format, students can learn skills such as operating audio-recording software and publishing files to Web sites. Students develop and demonstrate critical-thinking skills, apply research practices, become conscious of their own speech clarity and tendencies, and best of all, explore a new avenue of a technology with which they are somewhat familiar. Though it takes a little advance preparation, the enjoyment for students is well worth it. Also, the podcasts your students create serve as educational tools and models for other classrooms around the world. Technology is a powerful tool. Use it to enhance your curriculum and see just what an integral part of your classroom it can become.

Assessment

Overview, Chapter 11

11. **Darrell Yater,** an instructional specialist who knows the value of short-cycle assessments, presents great ideas for introducing students to high-stakes-test-style questions throughout the school year.

11. Short-Cycle Assessments

Darrell Yater
Cincinnati, Ohio

Recommended Level: Grades 6–8

Overall Objective: Assess your students' progress throughout the year using these short-cycle assessments.

Introduction

Short-cycle assessments are formative tools used to gather information that will inform classroom instruction. These assessments can be used in any middle school grade or content area. The standards assessed are chosen by the teacher when the assessments are created and are linked to the current unit of instruction. The key to using these assessments is to keep them short in length and have each question correlated to a specific standard. Once the tool is created, students complete the assessment, teachers grade the assessment, and then instruction can be differentiated to meet the specific needs of the learners.

Assessment Creation

Before I create an assessment, I study the state assessment. This will allow me to develop questions that mirror the type and format students will see on the high-stakes tests. Then, I match the questions from the state to the standards I am teaching in my current or upcoming unit. By analyzing the questions from the assessment linked to specific standards, I understand the expectation of that standard from the state's perspective. Then, I begin the process of creating the short-cycle assessment.

For reading, I choose an excerpt of text to use and create 10 to 15 questions based on the objectives stated in the unit. Each question is aligned to an objective from the state standards and mirrors the format. For other content areas, I develop the questions based on the standards and in the same format as the state test. As the questions are created, it is imperative that the corresponding state standard be linked to the question. I label the standard on the test document to allow students to see the standard. I share with my students the different standards from the state department of education and explain in student-friendly terms the meaning of each. In Ohio, one of the standards is reading process. I communicate that this is their ability to adjust their rate and purpose for reading and use strategies such as self-monitoring, questioning, and activating prior knowledge. During class, I will let them know whether an assignment or activity directly links to this standard. This may be as simple as verbally reminding them, posting a sign on the wall about what we will learn in the lesson, or putting a label on the top of an assignment.

The following is an excerpt from a reading assessment:

Read pages 62 through 67 in *The Outsiders* and answer the following questions:

Reading Process Standard (RP)

6. Which statement helps create a visual image for the reader?
 A. I climbed over the barbed-wire fence without saying anything else.
 B. It was a small church, real old and spooky and spider webby.

C. It was only last night that Dally and I had sat down behind those girls at the Nightly Double.

D. I was hardly awake when Johnny and I leaped off the train into a meadow.

Reading Application: Information (RAI)

7. Since Ponyboy and Johnny are hiding out in a rural community, if you wanted to look up information on farms, what would be the best resource to use?

A. Continue reading *The Outsiders.*

B. Use an encyclopedia and look up the word "farm."

C. Look up "farm" in a thesaurus.

D. Use the Internet to google "the outsiders."

Reading Application: Literary (RAL)

9. What does Ponyboy mean by the following statement on page 65: "There are things worse than being a greaser."

A. He doesn't want to be a greaser anymore.

B. He realizes that some people have harder lives than greasers.

C. He thinks he'd rather be a farmer now.

D. Being a soc is worse than a greaser.

The answer document allows for student input. They rate their level of confidence as they answer the questions by placing a checkmark in one of the first two columns. Their answer is listed in the third column. To grade them, I put a one in the standard column if the answer is correct and an X if it is incorrect. I can easily tally each standard column to get a raw score. Then, students analyze why they missed a question by reviewing the correct answer and determine whether it was a simple mistake or something in which they need more instruction. The data are then analyzed by me and the student to determine areas where additional support or enrichment is needed. This analysis can be as simple as using the raw score or adjusting the score and using the areas where students determine themselves to need more

instruction. In the beginning of the year, I use the raw scores, but as the year goes on and students become more proficient at their self-analysis, I allow their self-ratings to weight the raw scores.

Following is an example of an answer document:

Question	Confident	Unsure	Answer	RP	RAL	RAI	Simple Mistake	Further Study
1	✓		A			1		
2		✓	C			X	✓	
3	✓		B			1		
4	✓		D			1		
5		✓	A	X				✓
6		✓	C	X				✓
7	✓		A			X	✓	
8	✓		D	1				
9	✓		B		1			
10	✓		B	1				
11		✓	A		X			✓
12	✓		D		X			
13	✓		A		1			
Short Answer	✓				2			
Scores				2/4	4/6	3/5		

What to Do With the Data

Data collected from the short-cycle assessment must be able to be used in a timely fashion. Therefore, after scoring the assessment and noting the areas individual students need support in, I revise seating charts. This may seem unrelated, but to get to the students effectively and quickly, I need to have accurate groupings. Groups are designated

based on needs revealed by the assessment data. For example, students who need to develop skills in literary reading application are grouped together, and so on. Students are aware of how and why the seating arrangement is formed. Seats are arranged in groups of four to six at a table. In this manner, all students can focus on one area for direct instruction or may be focused on their group if small-group instruction is needed. Their understanding of this is important in their ability to see the value in the instruction and the relevance to themselves. When small groups have different assignments or when I meet with one group and do a different activity than with a previous group, students understand it is because I am differentiating based on the standard where they need the most support.

An important distinction that I feel needs to be made here is the concept of flexible grouping. Students are not relegated to a seat and left there permanently, nor are students identified with a weakness and permanently labeled as such. Students are grouped based on need and on data. These needs may change as the year progresses based on the content covered. Early on, a student may be identified as needing to develop his or her literary analysis because he or she struggles with understanding the importance of setting and inferring theme. Later in the year, the priority may shift to informational reading applications in the area of understanding structure and features of informational text. This student does not stay in a group focused on literary analysis all year. Students are regrouped with each assessment so that the instruction is timely and addresses the individual needs of the student.

I believe time is of the essence in the classroom. The flexible grouping allows for small-group instruction, which maximizes the instructional time. The revised seating chart based on assessment data means the groups are mostly formed. I am able to give instructions and begin to work with a small group while the other students are working more independently. Therefore, less time is spent with kids moving around the room trying to find their group assignment or work location for the day. Within any content area, instruction can be individualized in small groups, allowing teachers to work more directly with one group while early readiness groups are practicing or engaging in work to remediate and other groups are extending their knowledge through higher-level challenging activities.

Assessment is a powerful tool in my classroom and informs the instruction. I always begin by identifying the key objectives to be covered in a unit, build the essential understandings and questions from there, and then think about the types of assessments that are appropriate. Obviously, short-cycle assessments are part of that, but assessments based on multiple intelligences, formal and informal assessments, and summative and formative assessments are also included. A bank of instructional activities is also created. This is where the flexibility is so important. Based on assessment data, I may use some activities but not others or create new ones. A variety of whole-group and small-group instruction, as well as flexible groupings of students, allows me to respond to the data as frequently as possible.

As you can see, the short-cycle assessment is a piece of the puzzle and is intricately connected to many other pieces. When this is put in place with all of the other elements, the picture of student success becomes clear. I share this puzzle with my students, listen to them, and allow them to have a true understanding of how and why things happen in the classroom. The road to data-driven instruction has been much smoother with this approach. I feel like my students and I get farther down the road and arrive there faster than with any other system I have used.

Helpful Tips

- Create short-cycle assessments linked to specific objectives.
- Analyze the data and use them in a timely manner.
- Involve the students in the analysis of their own data.
- Create seating charts based on students of similar instructional needs based on data.
- Flexibly group students often.
- Provide small-group instruction to students based on short-cycle assessment data.
- Create instructional activities for all students based on assessment data.

PART II

Science and Math

Teaching Science

Overview, Chapters 12–18

12. **Michalle McCallister**, a science teacher from San Antonio, Texas, teaches general education, inclusion, and gifted education classes about the different energy sources around the world. In this lesson and throughout the school year, Michalle stimulates a love of science and an appreciation for natural resources in her students of all ability levels.

13. **Bonnie Garrett**, a seventh- and eighth-grade science teacher from Huntsville, Alabama, has her students convey their knowledge of the law of conservation of energy and its relationship to energy transformation through booklets they create. These fun foldables are a great hands-on activity for all skill levels.

14. **Tony Carmichael,** a middle school science teacher from Mundelein, Illinois, empowers his students as environmental stewards. As a class, Tony's students converted a degraded courtyard into a prairie wetland and learned about conservation management and natural history in the process.

15. **Susan Leeds**, a science curriculum teacher and leader from Orlando, Florida, gets her students excited about scientific inquiry by having them design their own experiments to get to the bottom of what makes "magic" toys work. Susan's students test toys such as fortune-telling fish, color-changing UV beads, Mexican jumping beans, and superabsorbent grow creatures.

16. **Thomas J. Bennett**, a sixth-grade science teacher from Wakarusa, Indiana, groups his students by ability level in this culminating enrichment activity to an astronomy unit. Bennett's students experiment with one variable as they create and launch rockets.

17. **Tammie Schrader,** a middle school science teacher from Cheney, Washington, engages her students in higher-level thinking by asking them to make connections between cell systems and other systems they are familiar with, such as schools or soccer teams. The students are more engaged because they are allowed to choose based on their areas of interest outside the classroom.

18. **Steven M. Jacobs,** an eighth-grade earth science teacher and former social studies teacher from Dundee, Michigan, inspires his class to dive into timely environmental issues by asking them to research and build a durable and ecologically conscious car. The project culminates in a commercial and can be easily adapted to cross-curricular work with the other core areas: social studies, English, and math.

℞ 12. Science Energy Lesson Including Differentiation and Inclusion

Michalle McCallister
San Antonio, Texas

Recommended Level: Grades 6–8

Overall Objective: The students will understand that through research they will develop their own perspective about different types of energy that can be used by the United States, and they will communicate their findings and point of view.

Standards Met (Texas):

Science: (TEK 6.9) The student knows that obtaining, transforming, and distributing energy affects the environment. The student is expected to (C) research and describe energy types from their source to their use and determine if the type is renewable, nonrenewable, or inexhaustible.

Materials Needed:

- Access to laptop computers
- Web sites
- Book and encyclopedias

In this lesson, students have a basic understanding of energy and know that we use different forms in everyday life. This project builds on a previous lesson of energy and energy transformation. Throughout the lesson, I focus on questions to guide the students and keep them on track:

- What type (or types) of energy does the United States use?
- What is the history and background of the energy source?
- What are the advantages and disadvantages of the energy source?
- What are the environmental and economic impacts of the energy source?
- How do you envision the use of this energy source in the future?
- What type (or types) of energy should the United States use for our future?

On Day 1, students review and discuss their present knowledge of the subject, and myths that surface are dispelled. Expectations and timelines are reviewed.

The first step for all students is to research their energy source or sources using a range of leveled printed materials and Web sites. The librarian and technology department staff assist in providing resources for the unit. The materials and Web sites are selected in advance to increase efficiency and decrease distractions: It's important for students to stay focused on their topics. After they start documenting their research and exhaust the resources provided, they may choose to use other sources. The timeline for this phase of the unit is generally five days.

If students are struggling with selecting their topic, I help them choose the one that most interests them by asking questions to narrow their choice or choices of energy sources and information. Students are able to hone in on the energy topic and the information resources that are most suitable. It is critical that student materials are appropriate for ability level. If students are struggling with researching an energy source in-depth, I provide direction as to what materials will help them answer their questions based on the gaps in their information.

In the second phase of the unit, students determine and prepare their projects; this generally takes three days. Students choose a format to show their understanding of the topic. In the regular education class and coteach class, students have the option to choose from one of three products for their final presentation: (1) performing a public service announcement, (2) creating an informational computer or keynote presentation, and (3) writing an opinion paper. Students with special needs have the added support of receiving an outlined template for their presentation. Students in the gifted and talented classes are invited to present at a conference on energy. The topic of the conference is, What type or types of energy should the United States use for a more efficient future? The conference culminates in a debate between the "experts." Students who prefer to work alone may choose to write a persuasive compare-and-contrast letter to the House Select Committee on Energy Independence and Global Warming. During this phase of the project, I meet with students and guide them on their project and analysis of the content.

All students are given creative freedom to choose how they present their research based on their interest and learning styles. The students present their findings and point of view in the option of their choice. They are graded using a rubric that is both individualized (based on their specific topic) and universal (based on the guiding questions). Students receive the presentation options and the rubric when the lesson is introduced.

The final phase is the presentation of their project. This takes two to three days in class to complete. Students who have chosen the computer presentation or public service announcement present them to the class. It is optional for students who chose the opinion paper to make a presentation. The debate is on the first day in the gifted and talented class. Student groups give their opening statements and then address questions from the audience, similar to the town-hall style debate from elections. Also, each group is given a chance to ask questions of their opponents. The debate ends with each group giving a closing statement. On the second day, students who chose to write the persuasive compare-and-contrast letter have the chance to read their letters to the class.

The final activity follows the day after the presentations. Students fill in a chart on the advantages and disadvantages of the energy sources.

Classroom Logistics

I teach three different types of classes in sixth-grade science: general education classes with inclusion, cotaught classes with a special education teacher for students with disabilities, and gifted and talented classes. Within these classes, I have students with a variety of learning styles, interests, and abilities. I take the time to know my students, so instruction focuses on all children learning the curriculum. The success rate of children in my classes is 96%. This means that communicating with parents, providing tutorials, and differentiating the instruction are critical to student success.

Differentiation Tips

This lesson has been differentiated in two ways: process and product. The process sets expectations of learning based on each child's ability level and encourages students to reach for the next level. This allows me to be the facilitator and mentor for the students and holds the child accountable for learning. I find that the best way to facilitate the student's learning is by preassessing and asking questions. The student's ability level and knowledge of the unit determine the entry point into the unit. I also believe you need to take the first week of school and really get to know your students; the better you know them, the easier it will be to differentiate for their needs.

Choice is another major component of differentiation, whether it is based on their readiness level, interest, or learning style. Choice also gives the students control of their learning, and they seem to be more motivated to learn. I try to give my students a minimum of two choices on the product to demonstrate their knowledge and understanding of the subject. They are also allowed to work in a small group (three to five students), in pairs, or alone. My goal is to challenge the student; choosing the easy activity is not an option. To this end, the choices within a classroom for students can vary. Students are provided with a rubric to help them understand the product expectations and how their work will be graded. Students do not need surprises and should know their effort produces the grade they will receive.

Managing the classroom for differentiated instruction includes the teaching of expected student behaviors, which are posted in the

classroom. The use of collaborative learning activities leads to a community of learners where I take on the role of facilitator. Positive behavior support is used in the classroom, which encourages students to make appropriate choices and it is my responsibility to acknowledge and praise their efforts. Anchor activities are provided for students who finish early, alleviating discipline problems because they are ahead of schedule. I have few if any behavior problems, and they are handled in the classroom with the support of parents.

Inclusion Tips

Preparing lessons for all learners takes planning. Finding appropriate level readers, Web sites, and modifying material on the subject can be difficult. ESL (English as a second language) teachers, special education teachers, and librarians are great resources. Students with visual-perceptual problems or lower-level reading skills who understand on grade level are provided with books on CD or digital files for their media players. Software that allows you to record online (e.g., GarageBand) is a great resource to use when working with these students; teachers can read and record tests or other material and students can listen to the material online or download it straight to their media players.

All lessons start with a discussion or activity to connect prior learning. Then I introduce typed notes projected on a white screen. I talk through the notes as we go over the information together. For the students who are visual learners, I also use pictures, graphs, drawings, and models, so they can follow along. Once students have the foundational knowledge for the lesson or unit, we follow up with some form of kinesthetic activity where the students are "doing" or are physically engaged to show their understanding of the lesson. Student success is at the center of each unit I plan for my students.

My school district supports both differentiated instruction and inclusion by providing training and mentoring for teachers who have chosen to use these techniques in their classroom. Both initiatives take time, effort, and energy. The long-term payoff is knowing that the learning stays with the students. Even more than having my students do well on the state standardized test, my goal is to create a love of science so that students will respect nature and our resources. Students may even

desire to have careers in this field one day. The biggest compliments over the years are from parents who say things such as "My daughter never liked or thought she was capable in science. When she left your class she found a love for the subject."

℞ 13. Creating Booklets Explaining Energy Transformation

Bonnie Garrett
Huntsville, Alabama

Recommended Level: Grade 6–8

Overall Objective: Students accurately explain the law of conservation of energy and its relationship to energy transformation, including chemical to electrical, chemical to heat, electrical to light, electrical to mechanical, and electrical to sound.

Standards Met:

National

> *Physical Science:* (B3.a) Energy is a property of many substances and is associated with heat, light, electricity, mechanical motion, sound, nuclei, and the nature of a chemical; Energy is transferred in many ways; (B3.d) Electrical circuits provide a means of transferring electrical energy when heat, light, sound, and chemical changes are produced; (B3.e) In most chemical and nuclear reactions, energy is transferred into or out of a system; Heat, light, mechanical motion, or electricity might all be involved in such transfers.

Alabama

> *Science:* (11) Explain the law of conservation of energy and its relationship to energy transformation, including chemical to electrical, chemical to heat, electrical to light, electrical to mechanical, and electrical to sound.

Materials Needed:

- Construction paper (Notebook paper or copy paper can also be used)
- Colored pencils or crayons
- Markers
- Scissors

The culmination of any dynamic or innovative lecture on any concept is the mastery of that concept by the student. What better way to assess the mastery of that concept than to allow the student to explain it to you using words and illustrations? Well, if you teach as many students as I teach in any given school year, then you understand that it is almost impossible to allow every student to explain every learned concept to you verbally. Even though I would love to have one-on-one conversations with each of my students about learned concepts, there is just not enough time for this type of interaction. Therefore, I had to think of some engaging ways to allow my students the opportunity to "talk to me" individually. One of these ways involves the incorporation of booklets, which are a type of foldable created by Dinah Zike (see www.dinah.com). Through this hands-on manipulative, students are able to construct their own booklets and become authors who will explain and illustrate identified concepts. In this particular activity, the identified concept happens to be the law of conservation of energy and its relationship to energy transformation.

To begin this activity, you will need to distribute a sheet of construction paper to each student in the class (be sure to have extra on hand because they tend to make mistakes the first time they construct the booklet). In addition to the construction paper, each student or each pair of students will need scissors, markers, and colored pencils or crayons. After all materials are distributed, I then explain and model the construction of the booklet with the students in an attempt to minimize the number of mistakes made, and for the most part it works! I instruct the students to fold the construction paper from left to right to make a "hotdog style" fold. After making the first fold, the students run their fingers or a pencil along the fold so it is apparent when they unfold the construction paper. It is a good idea to have them repeat this process after each fold in order to make their booklet collapse and close a little easier. I then instruct the students to unfold the construction paper and to make a new fold (the second fold) from top to bottom, which creates a "hamburger style" fold.

The next step is to tell the students to unfold the construction paper and refold it from left to right in the same manner that they folded it the first time ("hotdog style" fold). With the construction paper still folded, instruct the students to fold each end of the construction paper toward the center crease. After pressing firmly on the two new folds (one at each end), instruct the students to completely unfold the construction paper. At this point in the activity, you and your students should be able to see the creases of eight small rectangles in the unfolded sheets of construction paper. Now, you need to instruct your students to refold the construction paper from top to bottom in the same manner that they did the first time (the "hamburger style" fold).

With the paper folded in half, instruct the students to cut a slit along the center crease until they reach the other crease that runs horizontally. Advise them not to cut the entire sheet in half (this is the part that most students perform incorrectly). If the students correctly performed the last step, they should see a vertical slit in the center of the construction paper when they unfold it. Now, instruct the students to refold the construction paper from left to right in the same manner that they did before ("hotdog style" fold). Once it is refolded, the students should push the ends together so that the center collapses at the slit. Finally, have the students fold the four flaps to form a four-page booklet.

After each student has successfully constructed the booklet, I then hand out an individual copy of a rubric for completing the booklet. The rubric states that each student should give a written explanation of an example of each identified energy transformation and then provide a colorful illustration for each written explanation. The identified energy transformations for this activity coincide with the objective stated in the *Alabama Course of Study Bulletin* (2005) (see the standards met section of this entry), but you can use any learned concept or course standard for this activity. To be sure that my students understand the directions for the assignment, I provide them with one example to get them started; however, they cannot use my example in their booklet. The illustrations for the explanations may be drawn or retrieved from other sources, but all illustrations must be colorful. Most students can complete this assignment as a one-night homework assignment, but I typically allow the students two to three days to complete the assignment because the extra time produces better-quality work samples.

HelpfulTips

From my experience with using booklets, students of all abilities seem to enjoy creating them and, believe it or not, my students are always asking, "When are we going to do another booklet?" Learners love the opportunity to express themselves in this unique medium, which incorporates both written and art forms.

In addition to having extra construction paper on hand, I strongly encourage you to model the construction of the booklet with your students to facilitate visual learning (and help minimize mistakes). This activity is an intriguing way to enhance your students' abilities to express themselves in written and artistic form, and due to its versatility, it can be used with almost any concept or standard.

References

Alabama Department of Education. (2005). *Alabama course of study: Science* (Bulletin 2005, No. 20.). Montgomery, AL: Author.
Holt science and technology: Physical science (Alabama ed.). (2005). New York: Holt, Rinehart, & Winston.

℞ 14. Creating a Thriving Prairie

Tony Carmichael
Mundelein, Illinois

Recommended Level: Grades 6–8

Overall Objective: Empower students as environmental stewards to convert a degraded courtyard into a prairie wetland to teach concepts on conservation management and natural history.

Standards Met (Illinois):

Science: (11.B.3a) Identify an actual design problem and establish criteria for determining the success of a solution; (11.B.3b) Sketch,

propose, and compare design solutions to the problem considering available materials, tools, cost-effectiveness and safety; (13.B.3b) Identify important contributions to science and technology that have been made by individuals and groups from various cultures; (13.B.3c) Describe how occupations use scientific and technological skills.

Social and Emotional: (1B.3b) Analyze how making use of school and community supports and opportunities can contribute to school and life success.

English Language Arts: (5.A.3b) Design a project related to contemporary issues using multiple sources.

Materials Needed:

- A 20 × 20 foot area. Select an area that either can be fenced in or, as in the case of West Oak Middle School, is surrounded by classrooms that provide a natural barrier to potential predators.
- Within the 20 × 20 foot area, accommodations for a 10 × 10 foot pond. This will include a pond liner, rocks, an outdoor pond pump and filter, and plants for creating a high-quality wetland. Students can research the best layout for turtles or whatever creatures you desire to keep!
- Dirt, peat, and forest-leaf humus mix. This will be used to create a high-quality substrate to allow for turtles to nest and move around when outside of the pond.
- Old dead logs to serve as basking areas. These should be angled into the water to provide opportunities for the turtles to crawl out of the water and into the sun. Other dead logs can be laid down on the ground to provide hiding areas and shade for other organisms living in the area.
- Wetland plant plugs such as sedges and cattails. Once again, allow the students to research what types of plants should be planted.

- Turtles and other forms of wildlife. We worked closely with a nearby nature center (Wildlife Discovery Center). Some animals are protected, so consult with experts before getting too far ahead. Once nature centers, veterinary clinics, and other agencies learn that you are rehabilitating injured turtles, you will have turtles!

In 2005, West Oak Middle School received a number of grants to convert an old, degraded, and underused courtyard into a thriving prairie featuring a pond used to rehabilitate injured turtles and also to serve as a breeding ground for the endangered Blanding's turtle. In addition, native turtles injured by cars and other vehicles came to this facility for rehabilitation. Students were involved in all facets of planning, design, implementation, ongoing care of the turtles, and giving tours to visitors.

Working closely with students in the GATE (Gifted and Talented Education) program, seventh-grade science teacher Polly Kluvers, and the Environmental Club, I was able to secure a $20,000 grant in addition to over $16,000 in pro bono contractual work to turn an old, degraded courtyard at West Oak Middle School into a dynamic outdoor learning laboratory. In addition, this miniprairie became home to a group of endangered Blanding's turtles as part of a cooperative captive breeding program with the Wildlife Discovery Center in Lake Forest, Illinois.

For years, the courtyard at West Oak Middle School was nothing more than a vacant, concrete lot in the middle of the school (the courtyard is surrounded by classrooms but open to the sky). When I met with the GATE program faculty and students and our afterschool environmental club, I quickly realized that an incredible opportunity existed to help build environmental awareness and community pride within our school. We met with officials from the Wildlife Discovery Center and key officials from West Oak Middle School to form a plan. It was decided to turn this area of approximately 2,000 square feet into a living, breathing miniprairie wetland habitat. Some of the key features follow:

- Permanent pond and wetland. This is the centerpiece of the project. A group of endangered Blanding's turtles from the Wildlife Discovery Center are on permanent loan, and these animals

spend the spring, summer, and fall roaming free in this large out-door environment. Other permanent wildlife in the courtyard include American toads, western chorus frogs, green frogs, northern leopard frogs, tiger salamanders, smooth green snakes, and common garter snakes. Birds visit the many on-site feeders, and our butterfly gardens attract a host of insects including but-terflies, dragonflies, and many spider species.

- Prairie. A small remnant of prairie similar to what once typified Illinois is located near the pond. This prairie features various grasses, sedges, and low-lying plants and flowers.
- Butterfly garden. The endangered Karner blue butterfly was spotted during the garden's first summer of existence. Monarchs and several other species used this area throughout the summer months. We also observed praying mantis and many other insect species. Students kept journals illustrated with drawings and photographs of their observations; their pictures were taken back to the lab and identified using high-quality field guides. At the end of the semester, students submitted their own "field guides" of the plants and animals that live in "the courtyard."
- Nesting area. An area of dense vegetation (native plants) with a sandy soil substrate that provides optimal conditions for nesting turtles. Our project consisted of two components: (1) a sanctu-ary for the captive breeding of the endangered Blanding's turtle as part of a reintroduction program and (2) a sanctuary for injured turtles hit by cars. The courtyard provided a wonderful haven for convalescing turtles where they could recover in nat-ural conditions but without the threat of predatory mammals and large birds. Students assisted in the rehabilitation process, which included applying medicine, feeding, weighing, and so on. They took complete ownership of the process!

Grant money helped us purchase plants, seedlings, shrubs, the pond and associated equipment, labor costs, construction of tables and benches for students to sit on, and special drainage systems. The court-yard is now a primary component in Grades 5 through 8 and a featured part of the "tour" of the school for prospective and new students. The completion of the courtyard has been one of the most significant

accomplishments of West Oak Middle School in recent years. Most significantly, this project received the prestigious Certified Wildlife Habitat Site designation by the National Wildlife Federation. From a purely "school pride" standpoint, the amount of student interest has been overwhelming. Over 100 students were involved with the labor to create the courtyard, not to mention the months of planning and anticipation of the grand opening. This project gained local and national attention and was featured in several major newspapers. *Animal Planet* did a small feature on this project as well. When you combine teaching science in an outdoor laboratory, environmental awareness and stewardship, various partnerships with a conservation focus, and creating habitat to help save one of northeastern Illinois' most critically endangered reptiles (the Blanding's turtle), you have a recipe for what *Best Practices* is all about. Since its completion, the courtyard has already experienced great success: the hatching of 14 rare baby Blanding's turtles! The school was so excited that it had a schoolwide "name the turtles" contest. Suddenly, students were visiting the courtyard on a daily basis to observe wildlife in this unique and profoundly amazing learning "classroom."

The baby Blanding's turtles are now being raised in my science classroom, and we incorporate math into science learning. Students chart and graph the weekly weights that we take. We hope these baby turtles will be the founding stock for an important reintroduction in a rare open oak savanna in Lake County, Illinois. By weighing the turtles, students are learning about the importance of graphs, metric system measurements, growth rates, and how variables affect growth (diet, light, heat, etc.). Science has never been so much fun or so rewarding!

Grades 5 through 8 focus on various aspects of environmental education, and the courtyard has been an integral component of subject matters including science, math, and even language arts. Teachers at each grade level have realized that the courtyard provides an incredible learning opportunity for their students. In fifth grade, students conduct their weather stations in the courtyard and the Animal Adaptations unit is perfectly suited to studying the various animals that live in the courtyard. For example, the Blanding's turtle has webbed feet that allow it to swim effortlessly in the water. The box turtle, with a large domed shell and elephantine feet, is only found on land and, subsequently, spends

time digging into the ground. The seventh-graders study ecosystems, and by looking at the various ecosystems comprising the courtyard (prairie, wetland, scrub), they are able to make connections and learn that different habitats make up a single ecosystem.

In eighth grade, the Environmental Studies unit teaches how conservation management helps to keep fragile environments like the prairie healthy and biologically diverse. Students are actively involved in the hands-on tasks of landscape design, habitat restoration, and ongoing maintenance. If your school has an unused outdoor area, you might consider turning it into a mini-ecosystem! It doesn't have to involve turtles. Perhaps you want to build a butterfly garden, a koi pond, or just an attractive natural landscape. The possibilities are endless.

15. Building Scientific Relationships and Inquiry Skills Using Toys

Susan Leeds
Orlando, Florida

Recommended Level: Grade 6

Overall Objective: Engage students in scientific thinking by having them conduct experiments on common toys such as fortune-telling fish, color-changing UV beads, Mexican jumping beans, and superabsorbent grow creatures.

Standards Met:

National Science Education Standards: Science as Inquiry. Abilities necessary to do scientific inquiry; Understandings about scientific inquiry.[1]

Materials Needed:

- Fortune-telling fish
- Color-changing UV beads
- Mexican jumping beans
- Superabsorbent grow creatures

Objective

The objective is for students to develop the basic skills of scientific inquiry. For many sixth-grade students who enter my classroom, this is their first real science class. For the first month, I guide them to become comfortable and proficient in the process of scientific inquiry and experimental design, so as the year progresses, they will employ these skills throughout their lessons. To accomplish this, two things have to happen: First, we need to develop a community of learners who feel safe enough to share their thinking, and second, we need to give them experiences that are nonthreatening and fun to grab their attention. My goal in the early activities is to use simple toys that are not connected to any content to eliminate any fear associated with using unfamiliar materials. I find that using these toys encourages students to ask questions and test their ideas.

Magic Fish

The first week of school, after lab safety forms are signed and procedures are reviewed, I pull out the toys. I begin with the fortune-telling fish, little plastic fish that come in a sleeve. When you remove a fish from the sleeve and place it on your hand, it will curl in a variety of directions. Based on its movement, the description on the sleeve will tell you your fortune. We begin with students recording observations of the fish. Then, they are instructed to carefully remove the fish from the sleeve and place it in their hand and again record their new observations. This time, the fish curls or moves, and students giggle as they match the movement to their fortune. My goal is to elicit their questions about the fish's movement to help them focus on a testable question. Students share their questions, and we narrow it down to "What causes the fish to move?"

This sets the stage to develop their hypotheses (though I save the vocabulary until after they have shared their thoughts). Some students think it is the sweat in their hand, some think it is their pulse, and others think it is heat. We narrow down heat to body heat. In their notebooks, they write their own hypothesis about what causes the fish to move. How do we test their ideas?

In this discussion, we focus on what steps they would take to test their hypotheses. One rule is that no microwaves are allowed and they must keep the fish out of water. Each student develops one hypothesis and a plan to test it at home. Students return the next day with their results.

They all share and listen to each other's tests and are encouraged to ask questions. The real reason is never given unless a student happens upon it through experimentation. At this point, we are still keeping it simple, no controls and no constants. It gives me a chance to assess my students' ability to design an experiment without any set format. Before students leave, they are given a few white beads on a string and attach them to their backpack or wrist. Their homework is to observe the beads throughout the day and report their observations in class the next day.

Color-Changing UV Beads

Students were not told that they were given UV beads that change color when they are exposed to ultraviolet rays. When students returned to class, they explained that they changed color at different points of the day. As with the magic fish, we discuss their observations and narrow it down to a testable question, "What caused the beads to change color?" From experience, I can often anticipate their responses—some of which are often broad such as heat. We talk about what type of "heat" to help them focus on developing a testable hypothesis. Others will say "light," and we narrow it down again to the type of light. At this point, I am infusing the need to operationally define an independent variable without directly saying so. By having these discussions with students early in the year, we can use these as a frame of reference throughout our year. Students work in groups this time and develop a common hypothesis and procedure that they present on a whiteboard. With just these two experiments, we have introduced scientific vocabulary—*hypothesis* and *independent variable* (the thing they are changing to test what happens to their *dependent variable*)—by giving students something to hang it on. More important, we are building the skills of scientific inquiry.

Grow Creatures

Using superabsorbent grow creatures allows us to begin to expand student vocabulary of scientific inquiry. Most students have been exposed

to them, either the ones that come in capsules or the ones that grow at least 10 times their size, at some point in their childhood.

We talk about their experiences with grow creatures and discuss questions they may have about how they grow. I help to reframe the question to "What causes the grow creature to emerge the fastest?" Using the capsulated sponge creatures, students decide that using warmer water will facilitate their growth. The same hypotheses can be tested with the other types of grow creatures. I ask them how we could test their ideas, and each group develops a plan.

We talk about what things should stay the same in each test, such as the amount of water, the same color creature, and the same type of water. Students unknowingly have developed a list of constants or controlled variables. Now that they know that this is an important part of the experimental design process, we can give these a name, *controlled variables*—things that must stay constant in each test. We also need a way to record our data, how we will keep track. Again, students develop an effective method of data collection and recording by creating the tools that they will work with. Designing a table for recording data is another step to becoming proficient in experimental design. Using a *data table* to draw a *conclusion* is another skill added in this lesson, and they begin to use *evidence* to support their conclusion. Our skills are developing and becoming more comprehensive every day, and students will have a frame of reference as they design more and more experiments throughout the year.

Pet Beans

Each student is given a pet bean (Mexican jumping bean) to observe for a few minutes in class. It takes a few moments until they wake up and start moving. The challenge they face is to determine what variable can cause the pet bean to jump the most times in one minute. This is a deviation from the "what causes it to . . ." experiments. Students take their pet bean home and play around with different ideas (adding or taking away light, increasing or decreasing the temperature). They are also given a "How to Care for Your Pet Bean" pamphlet.

The next day, they share their observations and ideas, clarifying their own plans by listening to each other. In class, each student develops a plan to test one hypothesis. The next day, they share their data and their conclusions. All of these simple experiments involved low-cost

materials and played on the students' natural curiosity about phenomena that they may have overlooked had they not been in a science classroom. In a short time, I have been able to encourage my students to ask testable questions without directly teaching them the definition of *testable* or the vocabulary associated with the experimental design process. Yet they are able to demonstrate the beginning inquiry skills at an impressive level.

Keeping our discussions open and without right or wrong answers helps students feel free to share their ideas. It demonstrates that they are trusted and valued as learners. It diverts their thinking of teacher as dictator of learning and, I hope, helps them realize they are vested in the learning process. Benchmarks and standards can be met in a variety of ways, but I always look for the most effective method, and engaging students in inquiry accomplishes this goal. Wherever we are in our curriculum, students can ask the important questions about the concepts we are learning. They can dig deeper because they have developed their ability to carry out a meaningful scientific investigation based on a real question tied to our content. They can determine "why things happen" or "what happens if" because they can test their ideas. The teacher is not telling them. Inquiry requires your students to trust you, and encouraging inquiry demonstrates that you trust your students.

Helpful Tips

There are a ton of resources out there on inquiry. Read them all. Start small and don't give up. As Doug Llewellyn (2007) said with regard to reframing our lessons to become more inquiry based, "It is not a sprint. . . . It is a marathon." I am still in the middle of my race, and every year I find new ways to tweak my lessons so that students can employ the skills we began developing at the beginning of the year.

Note

1. Reprinted with permission. http://www.nap.edu/openbook.php?record_id=4962&page=105

Reference

Llewellyn, D. (2007, March). *Creating a Culture of Inquiry*. Presentation at the National Science Teachers Association national conference, St. Louis, MO.

≈ 16. It *IS* Rocket Science

Thomas J. Bennett
Wakarusa, Indiana

Recommended Level: Grade 6

Overall Objective: This activity directly correlates with the sixth-grade Indiana Academic Science Standards and is an exciting hands-on activity for students to apply their learned knowledge of astronomy to an extension physics exercise.

Standards Met (Indiana):

Science: (6.2.4) Students will inspect, disassemble, and reassemble simple mechanical devices and describe what the various parts are for. They will estimate what the effect of making a change in one part of a system is likely to have on the whole; (6.7.2) Students will use models to illustrate processes that happen too slowly, too quickly, or on too small a scale to observe directly, or are potentially dangerous; (6.1.7) Students will explain that technology is essential to science for such purposes as access to outer space and other remote locations; (6.3.1) Students will compare and contrast the size, composition, and surface features of the planets that comprise the solar system as well as the objects orbiting them; (6.3.17) Students will recognize and describe that energy is a property of many objects and is associated with heat, light, electricity, mechanical motion, and sound.

Materials Needed:

- Rocketry kits
- Rocketry "scratch" bulk packs
- Launching supplies
- Modeling glue
- Spray paint

As a culminating enrichment activity to our sixth-grade astronomy unit, students designed, assembled, launched, and tested model rockets. After background astronomy information was presented, homogenous student teams were formed based on ability levels. Before each team received their rocket, they had to submit a satisfactory "mission." The method of the proposal was differentiated: Some groups were to submit their missions in narrative form while others were given a template to follow. Each mission included four items:

1. A meaningful, creative astronomical name for their rocket based on scientific information presented in class

2. The variable that was going to be tested (i.e., fin alignment, engine size, parachute area, nose cone shape, mass of rocket) through the assembly and launch of their rocket

3. Their hypotheses as to how changing the variable would affect their "rocket system" as a whole

4. How they were going to evaluate and analyze the changes they made (i.e., trajectory of flight, time in the air, height attained)

After reviewing the missions, students, depending on their readiness level, were given either rocketry kits that included instructions and diagrams to aid them in the assembly process or various rocketry "scratch" parts to use in the design and assembly of their rockets. To tap the artistic abilities of students, they creatively spray painted their finished rockets. As long as their rocket was still in working order after the previous launches, each group was allowed three launches. Launches took place inside the middle school football stadium with students standing behind the chain-link fence for safety.

This particular project was funded through various grants, such as the ING Unsung Heroes Award and the Dekko Foundation grant, and with contributions from the local parent-teacher organization.

ꑒ 17. Teaching Students About Cells

Tammie Schrader
Cheney, Washington

Recommended Level: Grade 7

Overall Objective: Introduce students to cell systems by having them compare and contrast the cell system with a system they are interested

in and make connections among all parts of the system, such as input, output, energy transfers, and function of organelles. Science teachers will develop communities of science learners that reflect the intellectual rigor of scientific inquiry and the attitudes and social values conducive to science learning.

Standards Met (Washington):

Science: (1.2) Structures: Understand how components, structures, organizations, and interconnections describe systems.

Materials Needed:

- Computer lab
- Construction paper
- Glue sticks
- Colored pencils

This lesson builds on the teaching of cells as a system. Prior to this lesson, I taught students about cells and their organelles as a system for accomplishing what the cells need to do. I covered each organelle and had students build three-dimensional models of their cells and then gave them an oral quiz to ensure they understood what each organelle accomplished for the cell and, also, where energy and resources were exchanged. Students can be taught about cells in a variety of ways, and I used lecture and then hands-on building of models. Each group of students could build their models in their own way. The following lesson builds on the concept of the cell as a system.

For my lesson on systems, students were to pick a system of their choice. Each student could pick any system they knew and understood. Some examples of systems that were chosen by my students were a soccer team, an internal combustion engine, a paintball gun, and skateboarding. I have had many others and checked in with each student about their interests and ideas. After students made their choice, they were to research the components and match the parts of their system to the cell system. For example, DNA codes the information for the cell. The student would examine their chosen system—in this case, a soccer team—for the same component and tell me that the coach codes the information for the team. They built on this information by also

learning about energy transfer in their system and specific energy transfer types. This ability to pick their own system differentiated this instruction for the student, and their interest was high. Students had the opportunity to teach me things about systems I never knew. They also thought at a higher level because they had to analyze their system and look at their system in a new way. One of my favorite examples was the internal combustion engine because I know so little about it. The student really had to know his stuff and I did my own research to keep up with him.

After doing research, students needed to choose a way to present the information. I gave them various choices, again differentiating their instruction. Students could choose to write a paper, do a computer presentation, write a children's book, make a movie, or various other creative ways to teach what they knew. This was perfect because each student provided their own materials for their projects, with the exception of computers. Students were responsible for having their own supplies because they chose their projects. A positive outcome was that students were totally engaged.

Helpful Tips

You may consider having a two- to three-day timeline because some students finish before others. One way I dealt with this was to have a self-assessment and peer-assessment piece worked into the rubric for their scoring. When students finished early, they were to use class time to self-assess and then trade their project and have it peer assessed. Students checked each other's work and made sure that other students' projects were meeting the goal and that all organelle comparisons, as well as energy transfers, were there. The others did this on their own time.

I gave students with special needs a system they could understand quite readily, such as the classroom or the school. Another way I assisted these learners was to scaffold some of their system by building a worksheet that guided them to answer specific questions about their chosen system. This lesson met the needs of

all my students across the learning range by allowing learners to choose systems that challenged them. You could adapt this to a higher grade level by picking more complicated systems, such as a country or body of government. When working with a lower grade level, you could choose familiar systems for students.

❦ 18. The Sustainable Green Vehicle

Steven M. Jacobs
Dundee, Michigan

Recommended Level: Grades 8–9

Overall Objective: The Sustainable Green Vehicle project is an exciting hands-on activity that engages students in designing and promoting their own green vehicle for the 21st century. Through research and experiments, your students will investigate different renewable fuels and recyclable or renewable materials for vehicle construction.

Standards (Michigan):

Earth Science: (E2.2B) Identify differences in the origin and use of renewable (e.g., solar, wind, water, biomass) and nonrenewable (e.g., fossil fuels, nuclear [Uranium-235]) sources of energy; (E2.3A) Explain how carbon exists in different forms such as limestone (rock), carbon dioxide (gas), carbonic acid (water), and animals (life) within Earth systems and how those forms can be beneficial or harmful to humans; (E2.4A) Describe renewable and nonrenewable sources of energy for human consumption (electricity, fuels), compare their effects on the environment, and include overall costs and benefits; (E2.4d) Describe the life cycle of a product, including the resources, production, packaging, transportation, disposal, and pollution; (E5.4g) Compare and contrast the heat-trapping mechanisms of the major greenhouse gases resulting from emissions (carbon dioxide, methane, nitrous oxide, fluorocarbons) as well as their abundance and heat-trapping capacity; (E1.2B) Identify and critique arguments about

personal or societal issues based on scientific evidence; (E1.2f)
Critique solutions to problems, given criteria and scientific con-
straints; (E1.2g) Identify scientific tradeoffs in design decisions and
choose among alternative solutions; (E1.2j) Apply science principles
or scientific data to anticipate effects of technological design deci-
sions; (E1.2k) Analyze how science and society interact from a his-
torical, political, economic, or social perspective.

Materials Needed:

- Internet access
- Video camera
- Television

In this unit on the sustainable green vehicle, students will design a
vehicle that takes into account the life cycle of the vehicle, landfill and
air pollution, fuel mileage, use of sustainable materials, cost, climatic
issues, and aesthetics. This lesson will touch on a multitude of stan-
dards including Scientific Inquiry, Scientific Reflection and Social
Implications, Resources and Human Impacts on Earth Systems, and
Earth Systems. More specifically, the lesson will focus on sustainable,
renewable resources; impacts of pollution on a closed Earth system;
and economic, environmental, and social impacts of conservation.

A second portion of the lesson can be done in a cross-curricular
format with your fellow core-area teachers. The activities will focus on
sustainable, renewable energy sources and recyclable materials. The
interdisciplinary activities for math will focus on computations and
graphing; social studies classes will focus on persuasive writing to a
state congressional official, and English language arts classes will
focus on debates and persuasive writing formats. .

Research. Your students will complete research by way of the Internet,
scientific journals, and books. I recommend that you break students into
groups and assign topics based on difficulty of researchable informa-
tion. A list of sites could also be made in advance for the Internet search.
Their research will cover renewable and nonrenewable fuels (e.g., bio-
fuels, hydrogen, hybrid electric, solar, fossil fuels, compressed air, and
nuclear [Uranium-235]); recyclable and renewable materials for vehicle
construction (e.g., recyclable PET/HDPE products, biobased polymers,
corrugated materials, biofabrics, and renewable carbon fiber); life cycle

of vehicles from conception to landfill; air pollution created by differing fuels (i.e., carbon dioxide, methane, nitrous oxide); vehicle construction and usage costs; and current aesthetic and ergonomic trends.

To tie all of the information together, you should give a presentation or develop a lesson on global warming.

Optional Experiments. Teachers, this is where your students can get their hands dirty in an interactive "cooperative learning community." Your students, in a lab setting, will conduct experiments testing interior and exterior construction materials' durability, aesthetics, and climatic resistance (e.g., molded PET products, woven PET fiber products, various types of metals or alloys, switchgrass materials, and renewable carbon fiber). The experiments will also include material strength tolerances (e.g., tensile, fatigue, compression force). Your students should collect the data and then display their findings in graphical form. To save on materials that will be used, I recommend a lab station rotation.

In wind-tunnel experiments, your students will use toy vehicles to test different body styles and configurations to find variances in laminar flow and drag. Using this data, your students will be able to design the most efficient body style for reducing fuel consumption and pollutants. For my classroom, I made wind tunnels out of cardboard, straws, and acrylic plastic sheets (see Figure 18.1). I then used a fog machine for the needed smoke. Teachers, you can make a less complicated wind tunnel by simply using two fans and small pieces of tissue paper. Tape the tissue paper to a toy vehicle in different locations to show wind movement, and put the two fans on opposite ends of the toy car facing in the same direction. To further straighten the wind flow, cut boxes of straws in half and place them in front of the car. There are many examples and directions on the Internet for completing wind tunnels.

Assessment. Using differentiated instruction and "cooperative learning communities," your students should create television commercials using editing software (e.g., Apple's iMovie or Windows Movie Maker). Teachers, it is recommended that you assign roles for the completion of the project based on the abilities of your students. The commercial will prove, with graphical data, how their concept vehicle will mitigate environmental hazards (i.e., production and usage pollution, global warming, and landfill mass). Their

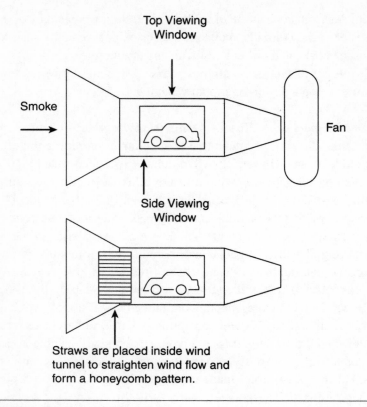

Figure 18.1 Wind Tunnel Diagram

commercial should also discuss environmental benefits of the materials used in construction, use a catchy jingle, and demonstrate how their sustainable, renewable fuel source works. The students can create schematic drawings of their vehicle by using CAD (computer-aided design) software, create hand drawings or use modeling clay to make a visual representation. My students use free CAD software (Google SketchUp, 2008) to design their vehicle. An alternative assessment would be to design an informational pamphlet or a poster presentation.

Cross-Curricular Lessons

Social Studies. Students will research and write a persuasive essay to a state congressional official that calls for legislation on an environmental

issue. It is important that the students discuss economic and geopolitical issues related to differing fossil fuels. An excellent topic to investigate is the creation of a five-cent deposit on all PET (polyethylene terephthalate) and HDPE (high-density polyethylene) plastic drinking bottles. These plastic containers are made from fossil fuels and are proliferating in our landfills. (Michigan State Standards P3.1 and P4.2)

English Language Arts. Students will hold debates on the information researched in regard to environmental issues and conservation. They will learn persuasive essay formats and peer review their social studies papers. (Michigan State Standards W.PR.08.04; W.PR.08.05; and S.DS.08.02)

Math. Students will perform mathematical calculations and graphing on landfill mass, fuel-consumption ratios based on type, material costs versus sale prices, and reasonable percentages for profit margins. (Michigan State Standards N.MR.08.10/11; A.RP.08.06; and D.AN.08.01/02)

Helpful Tips

- Students can perform market research to see what potential customers would desire in a motor vehicle.
- The commercial could be completed in a slideshow format with a digital camera if video cameras are not available.
- It is suggested that you help students think about alternative fuel sources by showing videos on compressed-air cars or flexible-fuel systems (i.e., systems that use multiple fuel sources— diesel, biodiesel, gasoline, or ethanol—such as General Motor's E-Flex system). Excellent videos can be found on YouTube.
- It is suggested that you show an advertisement of a green vehicle, currently being marketed, to give students ideas for their commercial.

Reference

Google. (2008). SketchUp 7 (Version 7.0.10247) [Software]. Available from http://sketchup.google.com

Teaching Math

Overview, Chapters 19–23

19. **Genia Webb**, a seventh-grade math teacher and educational consultant from Lexington, South Carolina, uses this fast and easy aerobic exercise to teach her students about coordinate geometry. "Remember," Genia says, "they are supposed to be more tired than we are at the end of the school day!"

20. **Lisa Wood**, a math coach from Newport, Arkansas, teaches her students the concept of elapsed time and how to represent it in an algebraic expression. Lisa's students have fun, and you will too, applying this concept to real-world activities such as going to the movies and baking a cake.

21. **Sarah L. Crose**, a math teacher from Lincoln, Nebraska, devised this fun and interactive activity to explain flow capacity to her seventh- and eighth-grade students. Laugh with the students as they cram into the school hallways to determine the difference between theoretical and practical hallway space.

22. **Amy Maxey**, a math teacher from Winston-Salem, North Carolina, with 14 years of experience, teaches her students about the Pythagorean theorem by having them calculate the quickest way through a maze.

23. **Eric Melnyczenko**, a seventh- and eighth-grade math teacher from Steger, Illinois, uses toy cars and a local museum exhibit to introduce his students to scale models. When applied to your classroom, Eric's lesson will give your students hands-on experience with statistics at a level they can understand.

19. Coordinate Plane Aerobics

Genia Webb
Lexington, South Carolina

Recommended Level: Grades 6–8

Overall Objective: Use aerobics to refresh students' knowledge of coordinate planes.

Standards Met (South Carolina):

Algebra: (2b) Explore relationships between symbolic expressions and graphs of lines, paying particular attention to the meaning of intercept and slope.

In this activity, you will function as the aerobics instructor. You will take your students, who happen to be enrolled in your aerobics class, through a modern-day workout. You will encounter all three workout stages and move progressively through the components of the coordinate plane along the way.

If you remember undergraduate school, you may remember professors telling us to use a "hook" to introduce concepts to students. I want to share my hook with you. Usually, I tell my students we are having a special guest. I ask them to stand up and spread out across the room. For safety purposes, they need to be at least an arm's length away from their classmates. I tell my students to close their eyes and to only open them after hearing an unfamiliar voice. Then, I begin in a totally different tone of voice:

Good morning ladies and gentlemen! My name is Missy Webb, and I am your aerobics instructor today. I am glad you decided to join my class. Before we begin, I want to prepare you for what you will encounter. We will be moving through a three-stage workout. First, we will stretch our muscles and loosen up. Then, we will move into low-impact aerobics. Finally, we will complete our workout with high-impact aerobics and a cooldown. Now, let's begin.

Stage 1: Warm-Up and Stretch

In preparation for graphing points, students will be able to identify the components (axes, quadrants, and origin) of the coordinate plane.

In this stage of the activity, you are simply reviewing the basic parts of the coordinate plane with students. Like stretching, this is done at a slow pace and in a very calming voice. You can do this once or twice to give them a feel for the activity.

What I say to my students during this stage:

Ladies and gentlemen, please stretch up toward the *y*-axis. Now, relax.

Now, please stretch out toward the *x*-axis. Now, relax.

Now, rest your hands at your origin (stomach). Please inhale. Now, exhale.

Stage 2: Low-Impact Aerobics

In this stage of the activity, you are working to develop student knowledge of the quadrants. You should demonstrate the location of the quadrants in front of them and allow the students to model with you (i.e., one—reach up to the right; two—reach up the left; three—reach down to the left; and four—reach down to the right). Using both arms, they will move through the quadrants at your command. The tempo speeds up slightly from the warm-up. Your counting should be done in rhythm.

What I say to my students and do during this stage:

Now we are going to move into our low-impact aerobics. Use both arms, and follow my lead. Ready? Let's go! One and two and three and four, and one and two and three and four.

As soon as your students become comfortable with the number sequence, switch the order in any way you like. This will keep them on their toes and create a need for them to pay close attention to what you are saying. Keep the same counting rhythm. This will allow your students the opportunity to correct their mistakes if they are in the wrong quadrant. It will also give you the opportunity to see who needs you to come help them get their bearings straight. Once this stage is complete, have the students rest at their origins.

Stage 3: High-Impact Aerobics

In the final stage of this activity, you will continue to develop student knowledge of the quadrants. This time you incorporate the legs as well. When you say *three,* a student should lift the left leg; and with *four,* a student should lift the right leg. This will start out slowly but finish up very quickly. It will look somewhat like Tae-Bo exercises to you and feel like it to your students. Remember, they are supposed to be more tired than we are at the end of the school day!

What I say to my students and do during this stage:

> Now we are going to move into the final stage of our workout, high-impact aerobics. We are going to get a total-body workout as we use our legs too. Ready?

Start out counting just as you did in Stage 2: "One and two and three and four, and one and two and three and four." This will allow the kids to practice using their legs a few times. After you give the students the opportunity to practice, you should begin to count out of order as you did in Stage 2. Remember, counting out of order will allow you to keep their attention. Again, feel free to switch the order in any way you like. You will conclude by counting like this: "One and three, two and four, one and three, two and four." Continue to repeat this a few times. Your students should be moving opposite limbs (right arm, left leg, and vice versa). Feel free to increase your speed after a few repetitions. They will get a kick out of what they are doing, and you will enjoy laughing with them.

Have students rest at their origins. You can end the activity there or go back to Stage 1 to close it out.

Helpful Tips

- Take on another character by giving yourself a silly name and changing the natural sound of your voice. You will be amazed at the interest and enthusiasm you will receive from your students because you are taking on a different personality for this activity.

(Continued)

(Continued)

- Laugh with your students. Do not let their silliness cause you to lose focus. As long as they are moving through the quadrants with you in an appropriate manner, they are doing what you have asked them to do. Some of your students will create their own movements but will be moving accurately through the quadrants.
- Model the exercises for them before each stage.
- The entire activity does not take any more than five or six minutes. You can extend or limit the time in each stage as you like.
- Use it as a reward and motivation in the future. Your students will enjoy the opportunity to move around and just be kids. Because this activity requires no preparation, you can review with them at anytime throughout the year. You can even use this when your students are not engaged and you need to refocus their attention.
- If you have students ask about doing coordinate plane aerobics, I have found that the best answer is "If we get through what we need to get through today, we can certainly do aerobics before you leave."

I hope you and your students enjoy this activity as much as my students and I do!

20. How Long Will It Take?

Lisa Wood
Newport, Arkansas

Recommended Level: Grades 5–6

Overall Objective: Students learn how to calculate elapsed time and apply that knowledge to real-world situations.

Materials Needed:

- Digital timers (one per group)
- Small manipulative clocks with hour and minute hands
- Data sheets on which to record information from timed events
- Dry-erase boards, markers, and erasers; or paper and pencil

- Movie guide from local newspaper
- Empty cake-mix box or a copy of the instructions from a cake-mix box
- Empty prescription bottle with dosage times recorded
- Copy of a junior high class schedule

Class-Time Requirements: One to two class periods

Try this activity to teach the concept of elapsed time. First, students will need to know how to use digital timers and will need a data sheet to record their information on. Then, divide students into groups of three or four. Write the following on the board: Elapsed time—How long did it take from start to finish? Discuss with the class that events have a beginning and an end. Some events last a long time and some only last a short while. Explain that they will participate in various activities that have a definite start time and end time, and they will record the elapsed time using digital timers. Within their groups, involve students in various activities (preferably outside the classroom), such as running, skipping, walking, and hopping a measured distance, while other group members keep track of time by using the prepared data sheets and digital timers.

As students finish their "events," ask the others how long it took to finish. After several events, ask them to recall the phrase written on the board in the classroom (i.e., elapsed time) that means the same as the current question. With some prompting, they should remember the phrase and, from then on, use the term on the board, reinforcing the use of correct terminology. Return to the classroom, and give students a hypothetical start time for each event. Lead them in calculating elapsed time by modeling several strategies. For the kinesthetic learner, use small manipulative clocks; for the spatial-verbal student, discuss counting hours and

then minutes mentally before recording elapsed time. For students who are more mathematical-logical, strategies for subtracting times should be explained. Students should understand that they are trying to find a difference, so they should set their problems up in a "later-earlier-difference" format before solving.

If they have difficulty doing this, ask them to set up an "easy" problem as an example and then apply the same process to a more difficult problem. For example, students may have trouble understanding how to solve the equation $43 - n = 17$, but they could quickly solve $4 - n = 2$. Students should practice using each strategy while it is being modeled for them, using the information on their data sheets. Small dry-erase boards work well when students are practicing new strategies because they provide teachers an opportunity to do a quick check of the work before students erase and get ready to begin the next problem. Instruct students in checking for reasonableness of their solutions when compared with data given in the problem.

Students will now use real-world situations, relevant to their age and interests, to determine elapsed times, start times, and finish times. The teacher should make sure students employ appropriate problem-solving strategies and should assess the clarity of written responses and reasonableness of solutions. Arrange students into groups of three or four to write about and solve one of the following situations:

- Given information regarding driving time to the theatre and a movie guide showing starting times for various movies, students should accurately schedule the departure time and return time. Students could choose to add additional stops, such as driving through a fast-food restaurant, as long as an indication is given as to how long it took to get food and that time is added to the elapsed time.
- Given a cake mix, students should read instructions to calculate appropriate start and finish times. Students should decide which size cake to bake, paying particular attention to the directions that state number of seconds or minutes required to blend, beat, bake, and cool.
- Given a medical prescription, students should determine the times at which a patient would take the first five doses of the day, considering the patient took the first medication at 6:07 a.m.

■ Given a junior high class schedule, students should determine the amount of time allowed to change classes, the length of "morning break," and the amount of time designated for lunch.

Assessment

■ Performance assessment began during the timing of outside activities. Students should understand the relationship between the questions, How long did it take? and What was the elapsed time?
■ After modeling each strategy, assess understanding by allowing students to practice the process on their own. If individual whiteboards are available, work can be assessed quickly as students hold up boards to show work.
■ Further assessment of understanding is made during the group activity, in which the teacher acts strictly as facilitator and instruction is conducted by way of asking appropriate questions that will guide students into using correct procedures.
■ Assessment concludes during the lesson's closing, when students present their work to the rest of the class. As students explain their work, the teacher listens closely for any misconceptions that need to be addressed.

A presentation by each group to the whole class, which includes an explanation of the strategies used and processes followed, will aid in determining understanding. This activity is a time to clarify misconceptions and is another opportunity to assess learning.

Helpful Tips

Potential Follow-Up Questions

■ How do you determine the reasonableness of your answer?
■ Which problem-solving strategy to determine elapsed time worked best and why?
■ Creating your own data, using hours, minutes, and seconds, explain the process of calculating elapsed time.
■ What consequences could result from not having an understanding of how to calculate elapsed time?

▧ 21. The Hallway Crush: How Full Is Full?

Sarah L. Crose
Lincoln, Nebraska

Recommended Level: Grades 7–8

Overall Objective: Students will make connections to transportation engineering by calculating floor area and using simulations to determine theoretical and practical flow capacity for their school hallway.

Standards Met (Nebraska):

Math: (8.2.3) Students will solve problems involving whole numbers, integers, and rational numbers (fractions, decimals, ratios, proportions, and percents) with and without the use of technology; (8.2.5) Students will apply strategies of estimation when solving problems with and without the use of technology; (8.3.1) Students will select measurement tools and measure quantities for temperature, time, money, distance, angles, area, perimeter, volume, capacity, and weight/mass in standard and metric units at the designated level of precision; (8.4.3) Students will use formulas to solve problems involving perimeter and area of a square, rectangle, parallelogram, trapezoid and triangle, as well as the area and circumference of circles; (8.5.2) Students will read and interpret tables, charts, and graphs to make comparisons and predictions; (8.5.3) Students will conduct experiments or simulations to demonstrate theoretical probability and relative frequency; (8.5.4) Students will identify statistical methods and probability for making decisions.

Materials Needed:

- Measuring tape or yardstick
- Masking tape
- Large sheet of craft paper
- Overhead spotlight (can be handheld by a student or attached to a ceiling brace)
- Calculators (optional)

Students explore *flow capacity,* an engineering concept, by calculating the capacity of their school hallway. They will calculate area and determine the number of students who are able to fit in the area (hallway). They will consider how capacity changes when given various conditions of pedestrian movement and apply their conclusions to vehicle flow on a street.

Students will reflect on a number of questions: What is the student capacity for the hallway outside our classroom? What is the practical student load for the hallway outside our classroom? What kinds of problems do crowded school hallways create (safety issues, tardiness, etc.)?

Activity 1: Calculate theoretical hallway capacity.

(See The Hallway Crush: Theoretical Capacity worksheet on p. 86.)
Calculate the hallway floor area:

- Select how much of the hallway you wish to measure. You could have groups of students work on different sections of the hallway or school. They could work as independent groups or bring their data to the large group and then find the mean of all the data.
- Select the units you wish to use for measuring (ft^2, in^2, m^2, etc.).
- Measure the length (l) and width (w). Apply the area formula for a parallelogram ($A = l \times w$).

Then, continuing with the same units of measurement, calculate the floor area occupied by a student standing still (with and without wearing a backpack):

- Use an overhead spotlight shining on a large sheet of paper. Have a student (without backpack) stand directly under the spotlight.
- Have another student trace the shadow cast by the standing student.
- Calculate the area of the cast shadow. Decide whether to use the area of the circle or the area of a rectangle closest to the cast shadow. You could calculate both and compare.
- Repeat the above procedure for the student wearing the backpack.

Use the student calculations to determine the number of students the hallway will hold. This is the *theoretical capacity.*

Activity 2: Simulate practical hallway capacity.

Simulate the standing capacity of the hallway (do this without backpacks):

- Measure off a 3- to 4-foot square or a circle with a 3- to 4-foot diameter.
- Have students stand in the measured space.
- Have the "crush" of students move forward in a shuffle style. Then, direct them to start walking using a more and more normal gait.
- What do we observe happen? How does this apply to the capacity of our hallway?

Activity 3: Calculate practical hallway capacity.

(See The Hallway Crush: Practical Capacity worksheet on p. 86.)
Calculate the floor area occupied by a student walking (with and without a backpack):

- Use an overhead spotlight shining on a large sheet of paper. Have a student (without backpack) take a stride and hold it while under the spotlight.
- Have another student trace the shadow cast by the "walking" student.
- Calculate the area of the cast shadow.
- Repeat the above procedure for the student wearing a backpack.

Use the student calculations to determine the number of walking students the hallway will hold. This is the *practical capacity.* How does this compare to our simulation?

Activity 4: Calculate the percentage of capacity.

Calculate the percentage of theoretical capacity when students are walking (both with and without backpacks):

$$100 \times \frac{\text{practical capacity}}{\text{theoretical capacity}} = \% \text{ of theoretical capacity}$$

Activity 5: Discuss and apply to real-world problems.

(See The Hallway Crush: Applications for Table Groups worksheet on p. 90.)

- Is it practical to expect that the actual hallway capacity will equal 100% of the theoretical capacity?
- What affects the actual capacity that is in our hallway at any given point in the school day?
- How could we determine the actual capacity of our hallway during passing periods?
- How does the percentage of capacity change given the activities at various points of the school day?
- Compare and contrast our hallway to a road or street with vehicles.
- How could we figure flow capacity for a street such as Fremont Avenue or 48th Street? (These are two streets near our school. You will need to substitute streets or roads near your school or that are very familiar to your students.)

HelpfulTips

While this lesson is targeted at middle level students, it could easily be adapted to upper elementary students who are studying area of parallelograms or circles. You might decide to complete only the theoretical capacity portion of the lesson. This lesson could be used with older or high-ability students. After collecting the data on theoretical and practical hallway capacity, these students could design a method to determine the actual capacity of the school hallway during passing periods. They could also research how engineers work with flow capacity and how that information helps in the design of highways, interstates, and city streets (intersections, on and off ramps, speed bumps, traffic signals, speed limits, etc.).

The concept of flow capacity can be extended to consider pedestrian flow at a particular venue (e.g., campus, shopping mall, or amusement park), air-traffic flow, waterways traffic flow, the product line of a factory, and other transportation problems. The following student worksheets may be used for Activities 1, 3, and 5.

Name _____

Period _____

Date _____

The Hallway Crush: Theoretical Capacity

Data Set Collection

 You will be collecting data for the amount of floor space. You will figure the floor space of our hallway. You will also be determining how much floor space a student occupies under prescribed circumstances. Devise a method to collect your data or use the models below.

Hallway Floor-Space Area

Hallway Width (w)	Hallway Length (l)	Work Space	Area of Hallway

Standing Student Data—No Backpack

(Use the grayed area when finding the mean of a group of students.)

Student	Standing-Space Measurements	Work Space	Floor-Space Area
1			
	Standing Mean Area (no backpack)		

Standing Student Data–With Backpack

(Use the grayed area when finding the mean of a group of students.)

Name _____

Student	Standing-Space Measurements	Work Space	Floor-Space Area
1			
	Standing Mean Area (with backpack)		

Name _____

Period _____

Date _____

The Hallway Crush: Practical Capacity

Simulation Notes:

"Walking" Student Data—No Backpack

(Use the grayed area when finding the mean of a group of students.)

Student	Walking-Space Measurements	Work Space	Floor-Space Area
1			
	Walking Mean Area (no backpack)		

"Walking" Student Data—With Backpack

(Use the grayed area when finding the mean of a group of students.)

Student	Walking-Space Measurements	Work Space	Floor-Space Area
1			
	Walking Mean Area (with backpack)		

Hallway Capacity Notes:

Name _____

Period _____

Date _____

The Hallway Crush: Applications for Table Groups

Data Gathered	Floor-Space Area
Hallway	
Standing Student (no backpack)	
Standing Student (with backpack)	
Walking Student (no backpack)	
Walking Student (with backpack)	

Small student groups consider the following questions (or selected questions) and then present their solutions, designs, and observations to the entire class.

1. What is the maximum capacity for our hallway?

2. Is it practical to expect our hallway to be efficient at 100% capacity?

3. What are some factors that affect the actual capacity of our hallway at any given point of the school day?

4. Design or describe how we could determine actual hallway capacity during passing periods.

5. Implement a class model for determining actual hallway capacity during various points in the school day.

6. How does the percentage of capacity change for different points in the school day?

7. Compare and contrast our hallway to a road or street with vehicles.

8. Describe or design a method to determine flow capacity for a street such as Fremont Avenue or 48th Street.

22. Maze Madness

Amy Maxey
Winston-Salem, North Carolina

Recommended Level: Grades 7–8

Overall Objective: Using the Pythagorean theorem, students will explore the differences between Euclidean distance and non-Euclidean distance when they calculate distances that an animal has traveled in a maze.

Standards Met (North Carolina):

Math: (3.01) Represent problem situations with geometric models; (3.02) Apply geometric properties and relationships, including the Pythagorean theorem, to solve problems.

Materials Needed:

- Graph paper
- Student handout: Maze Madness

- Students should have prior knowledge of the Pythagorean theorem before completing this activity.
- Each student will complete an adventure paragraph to determine his or her occupation. For each occupation, the career person uses a maze to train animals. Students will plot and connect coordinates consecutively to make segments that represent pathways in the maze. In the first maze the pathways are horizontal and vertical, but in the second maze the pathways are diagonal.
- Students will gain further understanding of vertical and horizontal change. The change in x and y values in the coordinate plane determine the side lengths for a right triangle. Vertical and horizontal change is also used in the slope formula. Students will discover that each diagonal shortcut for the second maze is the hypotenuse of a right triangle. The length of the hypotenuse is found by using the Pythagorean theorem. The length of the hypotenuse is shorter than the sum of the two legs of the triangle.

This application is true for all triangles; the sum of two sides of a triangle is always greater than the third side. Students will identify congruent, similar, and isosceles triangles in the second maze.

- Some students will oppose the idea of training animals, whereas some will view animal training as beneficial for future development. Allow time for students to express their thoughts on this topic. After completing this lesson, it is hoped that students will determine whether they would enjoy a career with animals and develop an opinion on animal training.

- Students will reflect on their construction.

 ❖ They will describe how they calculated horizontal and vertical lengths. Guide students to develop mathematical notation for vertical and horizontal change. For example, horizontal change is $x_2 - x_1$.

 ❖ They will explain how they used vertical and horizontal lengths to calculate oblique lengths. Throughout the process of comparing and explaining vertical, horizontal, and oblique lengths, student will communicate the Pythagorean theorem in their own words.

 ❖ Students will identify similar and congruent triangles from their construction. In addition, they will classify triangles as scalene, isosceles, or equilateral.

Helpful Tips

The process of constructing the maze may be difficult for some students. To demonstrate understanding, students can communicate the directions in their own words.

I thought I was a good teacher because I planned challenging problems for my students; in fact, some of the challenging problems have left students speechless. In reflection, I realize that many of my students sat quietly and stared at the problem because they were trying to understand what it was asking. Their quiet manner was not an indication that they were thinking.

The silence in my classroom frustrated me. I initiated a conversation about the challenging problems in an attempt to generate a class discussion; however, I controlled the discussion and proceeded to explain how to do the problem. My explanation was thoughtful and my presentation was organized, but now I realize that I barricaded a learning experience for my students. My students did not learn by passively watching me explain my learning experience. Students need learning experiences to use as a basis to solve future problems.

Maze Madness

I. Fill in the blanks with one of the choices or parts of speech.

I am a _____ and
zoo trainer, neuroscientist, veterinarian, psychologist
I am training a/an _____ to _____. In order to
animal *verb*
command the _____'s obedience, I will lead the animal
same animal
through two mazes. The maze consists of horizontal and vertical

movements. When the _____ gets to the end of the maze,
same animal
it will be rewarded with a/an _____ .
prize

II. Start at the origin and graph the following coordinates according to the compass direction. Draw segments to denote the path the animal travels in the maze. *Do all work on a separate sheet of graph paper.*

 $A \rightarrow B$: 4 units North

 $B \rightarrow C$; 3 units East

 $C \rightarrow D$; 6 units North

 $D \rightarrow E$; 8 units West

(Continued)

(Continued)

$E \rightarrow F$; 5 units South

$F \rightarrow G$; 5 units West

$G \rightarrow H$; 5 units South

$H \rightarrow I$; 12 units East

$I \rightarrow J$; 3 units South

$J \rightarrow K$; 4 units West

The _____ traveled _____ but would have traveled
 same animal total distance
_____ if it had gone directly from Point A to the prize at
 length of AK
Point K.

If the _____ eats _____ it will gain amazing
 animal vegetable
strength and will be able to break through secret passageways that
allow it to go from Point A to C, from C to E, and so on. Draw the
described segments on your graph, and then find their length.

AC = _____, CE= _____, EG = _____, GI = _____, IK = _____

Reflection Questions

1. Describe how you calculated the lengths in the first maze.

2. Explain how you found lengths in the second maze.

3. Name two triangles that have corresponding sides in the ratio of 2:1.

4. Name triangles that have congruent corresponding sides.

5. Name an isosceles triangle.

6. In your opinion, should animals be trained? Why or why not?

7. What is the purpose of training animals for the profession you chose?

℞ 23. Scale and Drawing Relationships

Eric Melnyczenko
Steger, Illinois

Recommended Level: Grade 8

Overall Objective: Using various models and maps, the learner will use proportions to solve problems involving scale. The learner will discover the actual measurements of the length of a vehicle and the distance from city to city.

Standards Met:

National Assessment of Educational Progress (2005): (G2e) Justify relationships of congruence and similarity, and apply these relationships using scaling and proportional reasoning.; (G2f) For similar figures, identify and use the relationships of conservation of angle and of proportionality of side length and perimeter.; (M2f) Construct or solve problems (e.g., floor area of a room) involving scale drawings.

Illinois. *Mathematics:* (7C.3a) Construct a scale drawing for a given situation; (9A.3c) Use geometric concepts and vocabulary in real life situations and buildings.

Materials Needed:

- Overhead projector
- Map of Illinois (or another state) on transparency
- Map of Illinois (or another state) for each student

- Calculator for each student
- Ruler for each student
- Die-cast model car (or another vehicle) with a scale on it, one for each student

This lesson uses various models and maps to show students the relationships between scale drawings and actual drawings. I used die-cast model cars, a map of the state of Illinois, and an exhibit at the Museum of Science and Industry in Chicago, Illinois, to show scale.

Steps

1. Distribute the rulers before the lesson. Ask the class whether they have ever been to the Museum of Science and Industry.

2. Talk about the Giant Heart, a walk-through heart exhibit at the museum, including its measurements, and show the exhibit on the overhead.

3. Distribute and show on the overhead a map of the state of Illinois; point to the scale that is at the bottom of the map, and ask the students to find the scale using the rulers.

4. Explain to the students that we can find the approximate distance across Illinois by using this scale and to do this we will use proportions.

5. Instruct the students to measure on the map between the two points given.

6. Demonstrate how to use a proportion to find the distance using a map. Learners will solve the proportion for the distance across Illinois.

7. Distribute model cars to the class, reminding them of the appropriate use of classroom materials, and explain that the model cars are created using a 1:64 scale and students are going to find the approximate length of an actual car.

8. Demonstrate on the overhead how to find the length of the model car and advise the class to find the length of their model cars.

9. Instruct learners to set up a proportion to find the actual length of the car. Then, show a problem to class via the overhead that deals with finding distances between three cities using a scale.

10. Revisit the Giant Heart exhibit and ask the class to find the height of an actual human heart.

The use of the Giant Heart exhibit and the map help this lesson to be applied to real-world circumstances. It shows the idea of using math outside of the classroom, which I find to be extremely important to show in my classes.

PART III

Language Arts
and Social Studies

Teaching Language Arts

Overview, Chapters 24–29

24. **Alicia Deel**, a special education teacher from Grundy, Virginia, recommends this technique for introducing your students to the elements of a story. Students first pick the characters, plot, and setting and then create an original story.

25. **Judy McEntegart**, a sixth-grade language arts teacher from Framingham, Massachusetts, groups her students into novel groups. Each group reads a different novel according to ability level. Students then discuss the time periods and the subjects of the novels with their peers who read different books. See Judy's lesson for a great sixth-grade reading list.

26. **Samantha Schwasinger**, an eighth-grade English teacher from Lincoln, Nebraska, incorporates creative writing work into her classroom in this fun unit on tall tales. Samantha's students complete a unit reading tall tales, such as *Paul Bunyan* and *Pecos Bill,* and then try their hand at crafting their own tall tales.

27. **Rebecca Stallings**, an eighth-grade English teacher and pre-advanced placement English teacher from Homewood, Alabama, invites her students to complete a service-learning project in conjunction with a research paper on a topic of their choice. Rebecca says her students "beamed with pride over the project's success and showed what teenagers can do to change the world."

28. **Sherry Crofut,** a middle school teacher from Rapid City, South Dakota, introduces her students to the difference between formal and informal writing by asking them to write a paper in the same way they would chat online or text message a friend. In this way, Sherry lets her students know that this type of language is a perfectly valid way to communicate but is not (usually) appropriate for a class paper.

29. **Samantha Schwasinger** hooks students into this lesson on writing techniques by having rock music playing on the radio when they walk into the classroom. Using music her students can relate to, Samantha teaches real-world examples of sound devices and descriptive-writing techniques.

▧ 24. Story Stew

Alicia Deel
Grundy, Virginia

Recommended Level: Grades 5–6, including special needs

Overall Objective: Introduce students to the concepts of character, plot, and setting by having them create their own stories.

Standards Met (Virginia):

English Language Arts: (8.3) The student will apply knowledge of the characteristics and elements of various literary forms; (9.2) The student will make planned oral presentations; (10.1) The student will participate in and report small-group learning activities.

Materials Needed:

- Apron
- Large cooking pot
- Wooden spoon
- Story
- Index cards, 5 × 7 inch, which will act as recipe cards (Multicolored index cards work best. Choose one color for characters, one color for plot, and one color for setting.)

Objectives

Students will master the following goals:

1. Recognize character traits and relationships among characters.
2. Recognize the plot in the story and how it is developed.
3. Recognize the setting in the story, where it is located, and the mood of the story.

Activities and Procedures

Teachers, begin by putting on an apron. Then, set your cooking pot and spoon on the desk. Next, tell the students that they are going to make story stew. Explain that a good story is like stew—it has a lot of ingredients. Reach into the pot and pull out an index card on which is written the word *characters*. Explain to the students that characters are who the story is about. Mention familiar stories and ask students to tell who the characters in the story are. Next, reach into the pot and pull out another index card on which the word *setting* is written. Explain to the students that the setting is where and when the story happens or takes place. Mention familiar stories and ask students to identify the setting. After that, again reach into the pot and pull out a final index card on which the word *plot* is written. Explain that plot is what happens in a story; talk about familiar stories, and ask students to briefly explain the plot. After this introduction of characters, setting, and plot, read a short story to the students. (One should choose a story with few characters, a well-defined setting, and a simple plot for this introductory activity.) After reading the story, ask the students to identify the characters and write them on an index card. They will then drop the card into the cooking pot. Stir it up. Then, ask the students to identify the setting and the plot in the same way. After stirring up the "ingredients," reach into the pot and produce a picture of the story that you just read to the students.

Tying It All Together

Ask students to create their own story stew by having them make up their own characters, setting, and simple plot description and write

them on an index card. Then, have them develop a story using their elements. For students who may be having difficulty (e.g., students with special needs in an inclusion classroom), provide index cards with story elements (characters, setting, plot) written on them, and let students choose one to write a story about. This activity could also be completed in groups, especially in an inclusion classroom with peer tutors. Each group could develop and make an oral presentation of their story.

Note

This lesson plan was modified from one taken from www.teacher.net.

▧ 25. Teaching Reading, Writing, and Differentiation

Judy McEntegart
Framingham, Massachusetts

Recommended Level: Grade 6

Overall Objective: Students will gain background knowledge related to World War II and the Vietnam War through a study of literature about the time periods.

Standards Met (Massachusetts):

Reading: (8) Understanding a Text: Students will identify and analyze sensory details and figurative language; (8.19) Students will identify and analyze characters' traits, emotions, or motivation and give supporting evidence from the text; (8.20) Students will identify and analyze the author's use of dialogue and description; (9) Making Connections: Students will deepen their understanding of a literary work by relating it to its historical background; (12) Fiction: Students will identify, analyze, and apply knowledge of the structure and elements of fiction and provide evidence from the text to support their understanding.

Composition: (19) Students will write with a clear focus, coherent organization, and sufficient detail.

Materials Needed:

- *Snow Treasure* by Marie McSwiggan (2006)
- *Charlie Pippin* by Candy Dawson Boyd (1988)
- *The Journal of Patrick Seamus Flaherty* by Ellen Emerson White (2002a) from the My Name Is America series
- *The Journal of Scott Pendleton Collins* by Walter Dean Myers (1999) from the My Name Is America series
- *Where Have All the Flowers Gone* by Ellen Emerson White (2002b) from the Dear America series
- *Early Sunday Morning* by Barry Denenberg (2003) from the Dear America series
- *A Boy No More* by Harry Mazer (2006)
- *The Art of Keeping Cool* by Janet Taylor Lisle (2000)

I assign my students the novels, keeping in mind their reading abilities. Each student receives the book and a calendar where the assignments are "chunked" with the journal questions on the back. My inclusion students read *Snow Treasure* (McSwiggan, 2006) because it is a fourth-grade level text and the story is straightforward. The special educator is also able to supplement information for the book in the support classes and help students answer the journal questions. The journal questions are designed to elicit understanding of the story and the character's reaction to the events. In the same class, I have four groups read *Where Have All the Flowers Gone* (White, 2002b), *Early Sunday Morning* (Denenberg, 2003), *The Journal of Patrick Seamus Flaherty* (White, 2002a), and *The Journal of Scott Pendleton Collins* (Myers, 1999). When the students finish the books, I pair them according to which book they read. Those that read *Where Have All the Flowers Gone* team up with readers of *The Journal of Patrick Seamus Flaherty*, and readers of *Early Sunday Morning* and *The Journal of Scott Pendleton Collins* partner together. In fact, *Flowers* and *Sean* are journals of a brother and sister.

In another class, I have three groups read *Charlie Pippin* (Boyd, 1988), *The Art of Keeping Cool* (Lisle, 2000), and *A Boy No More* (Mazer, 2006). At the end of the unit, I pair one from each group to share. *Pippin* is related

to Vietnam, and *Cool* and *Boy* are related to World War II. In this way, students can share information about the settings and characters. In addition to reading the books and answering the journal questions, students meet for three literature circles. The first literature circle is focused on the main character and the setting. In their circles, the students discuss the main character, identifying character traits and finding evidence of that trait in the book. They identify the details of the setting. Then, we discuss the importance of the setting in a historical fiction book. For the other two literature circles, the students meet three days before the circle date to choose roles. The roles are discussion director, vocabulary enricher, character captain, literary luminary, connector, and illustrator.

For the most part, the books are sixth-grade reading level, so I offer my students who demonstrate readiness for higher-level work a challenge activity. They can choose from exploring and creating a project on the culture of the 1940s or 1960s by researching music, dance, movies, fashion, toys, or food from the decade. With this information, they write a one- to two-page paper, compose three poems at least eight lines each or one poem with three stanzas, or create a visual. Another choice is to research or read a biography of an important figure from that decade: President Johnson, President Roosevelt, Rosie the Riveter, General Patton, General Eisenhower, or the Beatles. Another option is to design their own project. They submit their plan in the middle of October with completion due the second week in November. These students share their projects with their section.

References

Boyd, C. D. (1988). *Charlie Pippin.* New York: Puffin Books.

Denenberg, B. (2003). *Early Sunday morning.* New York: Scholastic.

Lisle, J. T. (2000). *The art of keeping cool.* New York: Aladdin.

Mazer, H. (2006). *A boy no more.* New York: Simon & Schuster.

McSwiggan, M. (2006). *Snow treasure.* New York: Puffin Books.

Myers, W. D. (1999). *The journal of Scott Pendleton Collins.* New York: Scholastic.

White, E. E. (2002a). *The journal of Patrick Seamus Flaherty.* New York: Scholastic.

White, E. E. (2002b). *Where have all the flowers gone.* New York: Scholastic.

℞ 26. Tall Tales

Samantha Schwasinger
Lincoln, Nebraska

Recommended Level: Grade 8

Overall Objective: Teach students about the elements of a "tall tale" and enable them to write their own.

Standards Met (Nebraska):

English Language Arts: (8.2.2) By the end of eighth grade, students will use creative and critical-thinking strategies and skills to generate original and meaningful products.

Materials Needed:

Collection of tall tales starring different characters. Examples include

- "They Have Yarns" poem by Carl Sandburg (in *Elements of Literature)*
- "Pecos Bill and the Mustang" by Harold W. Felton (in *Elements of Literature*)
- *John Henry* by Julius Lester (1994)
- *Paul Bunyan* poem by Shel Silverstein (1974)
- *American Tall Tales* by Mary Pope Osborne (1991)
- *Elements of Literature: Second Course* (literature textbook)

Information on the origins of chosen tall-tale characters

Our curriculum is so tight, it is difficult to incorporate any creative-writing work. However, one day while looking through *Elements of Literature,* I came across a collection of tall tales. I remembered loving to read tall tales when I was in school. Riding on the warm memory of my own tall-tale learning experience, I checked my plans and found some time that could be spent in the spring reading and writing tall tales. Paul Bunyan was always one of my favorite characters, so I was

delighted to see a poem written by Shel Silverstein (1974) (another of my favorites from my days as a student) about Paul Bunyan! I decided Paul would be a wonderful place to begin. However, before digging into reading the poem, I knew I should access the prior knowledge of my students.

For a journal entry, when students came into class, I had them write about their knowledge of tall tales. I wanted to know whether they knew what tall tales were and whether they could give me some examples. I discovered that my students did not necessarily know how to define what a tall tale was but were pretty successful at identifying famous characters. In light of these data collected by students, the next order of business became the task of defining a tall tale. Looking more closely at some of the other, and when I say "other" I mean "unfamiliar," selections in the literature book, I came across Carl Sandburg's poem "They Have Yarns." On the page with the prereading activities is a definition of a tall tale. The literature book defines a tall tale as "an exaggerated, far-fetched story that is obviously untrue but is told as though it should be believed" (*Elements of Literature,* p. 497). I decided to begin with reading the Sandburg poem and discussing the definition of a tall tale as provided in the literature book.

This definition became the foundation for every discussion we had about tall tales and what tall tales were. As we moved through the three characters I had chosen for my students to study, Paul Bunyan, Pecos Bill, and John Henry, I began to feel that they had a firm grasp on the characteristics of a tall tale. I used the book *American Tall Tales* by Mary Pope Osborn (1991) as a resource with my students to provide them with some background information on each of the characters we were studying. We also did some comparing and contrasting of the different stories and characters to reach a deeper meaning of this form of literature.

After about a week of study, I believed that my students were ready to move to the creative piece and write their own tall tales. Understanding the diversity in my class, I decided to allow students to write their tales in pairs. We discussed what we thought the assignment should look like. We decided that each pair could write either a poem or a story. Depending on what each group chose, there would be a separate list of guidelines. The guidelines we developed for the story became a checklist of items each tall tale should include. These items were exaggerations, one main character, illustration(s), a plot with a problem and

its solution, personification, real-life circumstances or objects, a story map, a cover, and a tagline. For the poem, we decided to use Silverstein's (1974) "Paul Bunyan" as a template. The checklist was similar to that of the story, but we added that the poem had to be at least 20 lines long, which equaled six stanzas based on the template.

The writing process was difficult for the students who were more literal thinkers. However, everyone muddled through the assignment and ended up with a really fun and creative final product. A few of the titles were "Giggi McGoogle," "Shavan Vanala," and "Sarah Shrine." Studying tall tales turned out to be a nice break from the never-ending requirements of standards and CRTs.

Helpful Tips

Breaking down each tall tale was helpful in the writing phase of this assignment, especially for those students who are literal and need step-by-step directions. I had a wide variety of stories to share with my students, from written stories and poems to a video where the story was read and the pictures from the book flashed across the screen, as well as other videos where the students could see how different people interpret the different characters. An outstanding Web site to support a unit on tall tales is American Folklore (Schlosser, n.d.). There are dozens of different stories about the most famous characters. Also, you can focus your unit on local tall-tale characters and stories! There is a wealth of information.

References

Elements of literature: Second course. (2000). New York: Holt, Rinehart, & Winston.

Lester, J. (1994). *John Henry.* New York: Puffin Books.

Osborne, M. P. (1991). *American tall tales.* New York: Alfred A. Knopf.

Schlosser, S. E. (n.d.). *American folklore: Tall tales.* Available from www.americanfolklore.net/tt.html

Silverstein, S. (1974). *Where the sidewalk ends.* New York: HarperCollins.

▨ 27. Service-Learning Research Project

Rebecca Stallings
Homewood, Alabama

Recommended Level: Grade 8

Overall Objective: Students will develop a service-learning initiative that encourages the habit of service and supports civic engagement in collaboration with academic learning.

Standards Met (Alabama):

English Language Arts: (4) Apply strategies appropriate to type of reading material, including making inferences to determine bias or theme and using specific context clues, to comprehend eighth-grade informational and functional reading materials; (7) Compose a business letter, including heading, inside address, salutation, body, closing, and signature; (8) Write in narrative, expository, and persuasive modes with attention to descriptive elements; (13) Combine all aspects of the research process to compose a report.

Materials Needed:

- Computers with Internet access for research
- Media-center databases
- Paper
- Cameras
- Index cards
- Notebook

Eighth-grade English language arts students learn about the research-paper process while conducting and documenting three hours of community service related to a social issue of interest. Students complete interest surveys and choose research topics such as homelessness, cancer, illiteracy, the elderly, diabetes, poverty, animal abuse, and mental retardation. Students write the paper, including a separate journal reflecting hours of service for the chosen cause, and present research in a community showcase.

As a middle school teacher, I know that sometimes academics can be the last thing on a student's mind. In fact, my eighth-graders tend to be self-absorbed, which is quite typical of the egotistical adolescent who thinks the world revolves around him or her. "Who's going to the homecoming dance?" "Did you hear about the boy who broke up with his girlfriend?" or "Oh no! I've got a zit on my chin!" are usual thoughts raging through teenagers' minds as they sit in my English class. Over the years, I have pondered how to make them see that, even at their age, they can make a huge difference in the world. Eighth-grade service-learning projects create a sense that they can contribute to the world outside of their teenage dramas, while seeing a bigger picture that hopefully will lead them to becoming responsible, caring adults.

When I was a candidate for National Boards for Professional Teaching Standards in 2001, I networked with some of the best teachers in the Birmingham area. I developed the idea of service-learning research projects as part of my portfolio entry and expanded it to meet the needs of my students because of the potential for a learning impact on students. As a result, all eighth-graders in my school are required to complete a service-learning project before they attend the high school in our district. This prepares them for the many service-oriented clubs and activities for high school- and college-level students. Furthermore, the high school English teachers require service hours for our students as a continuation of this project.

To begin the unit, I read the book *It's Our World, Too!* by Phillip Hoose (1993). The book chronicles several teenagers who felt a passion for a cause and completed a service project to help the cause. The book is inspiring, interesting, and easy to read in a few short days in the classroom. My students sit amazed at how a simple idea developed into helping so many hundreds and thousands of people. The book tells about Dewaina Brooks, a young girl in Dallas, Texas, who walked by a homeless shelter on the way to school every day. She made a peanut butter and jelly sandwich each day for her own lunch and thought, "Why not make an extra one for the homeless people?" Well, her idea opened an invitation for her friends to come together in her kitchen and make sandwiches while dancing and listening to music. Soon, as her weekly "dance" meetings grew, she fed thousands and was recognized for her contributions, which started as such a small gesture.

After I read the book to the class, my students complete a survey of interests and motivators to discover what they would like to do for a service project. I confer with them individually to lead them to a topic choice. When they decide on a topic, they begin the legwork of calling and setting up dates and times for community service. While this part of the project begins, I conduct weekly lessons working step-by-step through the research-paper process. First, I teach a lesson on deciding on a topic. When they decide on a topic, they must narrow the topic down and develop a thesis statement. It seems that a thesis can sometimes be a huge hurdle for students, but once they create a working thesis, they focus on getting the information needed for the paper.

We schedule a meeting with our media-center specialist, and she teaches my students how to access databases such as the Alabama Virtual Library (www.avl.lib.al.us), which is an online database of hundreds of resources. Each student receives an AVL (Alabama Virtual Library) card, a username, and a password. They can access AVL from any computer with Internet access. Preparing students for the future must involve teaching research and database skills. Next, I teach note cards, source cards, outlining, drafting, revising, editing, and publishing. Through the rigor of the process, the final product is a polished paper backed by research-based evidence on the social issue.

Besides the writing and research lessons, one of the biggest obstacles for students to learn in eighth grade is proper MLA (Modern Language Association) formatting and citing. For some reason, the students believe that it is not important to cite sources. This is where the lesson on plagiarism is imperative. Usually, I have to return the first draft with a "zero" on it for them to believe how serious I am about citing sources. My students say I turn into the "plagiarism monster" when I teach this lesson. I must do whatever works to prepare them for the next level! When students find a local agency for community service, they must complete the three hours of service. Several particular projects stand out in my mind as I think back over the years. In the past, several students have served food at the Jimmie Hale Homeless Mission in downtown Birmingham. One of my students discovered while serving food that a fellow student from Homewood Middle School was a resident at the shelter. At that moment, lightbulbs went off in his mind. He shared with me, "I always thought that homeless people

were drunken bums lying on the streets, but now I see that anyone can be homeless at one time or another."

This epiphany allowed him to truly understand his topic and reflect in a way that exceeds what any lesson in the classroom could ever do. I've always believed that sometimes students learn best outside the four walls of the classroom. This was a prime example of authentic learning. Another student, John, developed an interest in Down syndrome because there were two students in the classroom with Down's. John was fearful of students with disabilities and didn't understand how they could be in the same classroom with him. He wanted to learn more about it to identify with his classmates, so he volunteered at the local elementary school in a prekindergarten class helping a student with Down's. His mother knew a 36-year-old with Down's back in Monroeville, Alabama, and as an extension of this project, she arranged an interview for John with the man.

John compared his visit with the 4-year-old to the 36-year-old and concluded that "People are people no matter what." He grew in his understanding of Down syndrome and, in the process, helped others to learn about a very common and misunderstood disability. Last, Kathy, a bright student, chose drug abuse as her topic because her father was in prison because of drug usage. She lived with her mother and could not arrange the hours outside of class because of her mother's work schedule. Kathy's lifelong goal was to become a teacher, so we brainstormed ways that she could fulfill her community service within the school, thus possibly experiencing a career-path choice for later down the road.

She decided to teach a lesson on drug abuse to several students who received special education services for varying disabilities from autism to mental retardation. She taught them using pictures and allowed them to make a book revealing their learning. The class came to my classroom to share the books, which was beneficial to all students. Kathy solidified her decision to become a teacher and now is a high school student passionately considering her college possibilities. These students are just a few of the hundreds who found a social issue, discovered more about the topic by helping others, and decided on a professional path because of the service-learning project.

After completing their research papers, my students created a multimedia presentation of the research and service hours to show at the

annual Homewood City Schools Foundation Showcase in the spring. This event spotlights positive events, lessons, and activities in our school system for the community to see in an open-house format. My students presented their projects in a classroom in front of parents, grandparents, board members, administrators, and fellow students. They beamed with pride over the project's success and showed what teenagers can do to change the world. In a survey following the service-learning research project, over 92% of my students believe that young people can have a positive impact on schools and communities. Also, 88% agreed that they will volunteer to help others who are having problems or are in need of help. In all, the vast majority felt that this project helped them learn more about their topic than they thought possible. Eighth-graders emerging out of their self-absorbed world to help others proves that the service-learning project was beneficial.

This experience helped my students develop lifelong concerns for humanity that will hopefully continue for years to come. My students gained the experience of serving others and discovered that with just a small effort, they can make a difference in the human race. In a world where negative publicity constantly dominates the news about young teens shooting, stabbing, or abusing drugs, my students chose to defy the odds while doing positive deeds. Just as in *It's Our World, Too!* Homewood Middle School's students proved that young people can and will make a difference in our world's future.

Reference

Hoose, P. (1993). *It's our world, too!* Boston: Joy Street Books.

28. Comparing Formal and Informal Language

Sherry Crofut
Rapid City, South Dakota

Recommended Level: Grade 8

Overall Objective: Teach students when to use formal and informal language. More specifically, I target the use of text- and instant-messaging language that seems to creep into English papers.

Standards Met (South Dakota):

English Language Arts: (8.W.1.1) Students can compose narrative, descriptive, expository, and persuasive text of five paragraphs; (8.W.1.2) Students can revise writing for ideas and content; Students adjust their use of spoken, written, and visual language (e.g., conventions, style, vocabulary) to communicate effectively with a variety of audiences and for different purposes.

Materials Needed:

- Paper
- Pencil or pen

Students write a descriptive essay about their summer vacations. I set the stage by reminding them that in this descriptive essay, I want to know all the details, so I have a good understanding of their summer. Then, I throw in a twist. I want the essay written as though they are texting or chatting online with me, and I tell them I know many abbreviations. This gets their attention. I advise them to use school-appropriate language. The students who have never chatted or used text on a cell phone write about their vacations in essay form. They are given half of the class period to write, and they are enthusiastic about this assignment.

I ask whether they think it is appropriate to send a letter written in this format to their grandparents or other older relatives. They usually say no because their grandparents wouldn't understand what they wrote. I ask about sending a letter to a future employer written this way and then ask about a paper in English class. I question whether using informal language is a valid form of communication. They are often worried to say that it is, but I validate that it most certainly is. They are able to get their point across quickly. I assure them that when I chat or text, I often resort to the same lingo. I teach them that there is a time and a place for informal language and English class is not that time or place. They need to be assured that texting and chatting have value, and they like knowing I do them as well.

I set expectations: Use complete sentences, proper spelling, capitalization, and no abbreviations. I also make it clear why this is important. I don't want my students to struggle in high school or college because

they are weak in their writing skills. I don't want them to appear less intelligent in the real world because their writing isn't adequate. The students then rewrite the paper in five paragraphs using formal language. Those who didn't write it in chat or text format write an explanation of their technology situation. Do they have computers or cell phones? If so, how often do they use them, and what applications do they use? If not, do they access computers at other places? I have them write until the end of the period, and often they don't finish. This paper gives me a good idea of their writing skills. The essays are very interesting to read, both for the content and to witness their skill at texting and chatting. I learn who is using technology regularly. Even though I teach in a poverty-level school, the number of students with cell phones and track phones with the text feature has increased dramatically over the last few years. I give a participation grade for this assignment, because I use it primarily to assess the strengths and weaknesses of student writing. I also do not want to penalize those students who don't chat or text. I teach my writing classes largely using the Writer's Workshop approach; future assignments include teacher conferencing, and I work with students one-to-one to improve their skills. The essays about their summer give me a topic to discuss to get to know them better.

29. Teaching Descriptive Writing Using Song Lyrics

Samantha Schwasinger
Lincoln, Nebraska

Recommended Level: Grade 8

Overall Objective: Students will be able to identify figurative language and sound devices in song lyrics and identify the importance of figurative language and sound devices in description in a practical application.

Standards Met (Nebraska):

English Language Arts: (8.2.2) By the end of eighth grade, students will apply a process to develop and improve written texts as appropriate to the intended purpose, audience, and form.

Materials Needed:

- The following CDs: System of a Down *Toxicity* (2002), Sister Hazel *Lift* (2004) and *Chasing Daylight* (2003)

- Copies of song lyrics
- Examples of figurative language and sound devices

It is very difficult to engage students, especially middle school students, in a lesson on figurative language and sound devices. The challenge lies in making the lesson memorable. I was in the car driving home one day, listening to the radio, when the idea struck me. I should use song lyrics to show students how figurative language and sound devices are a part of their everyday life. The specific song that inspired my idea was "Aerials" by the rock band System of a Down (SOAD, 2002). I knew that a lot of my students listened to rock music, so this song would be perfect to introduce my lesson on figurative language and sound devices. I also knew that the song did not have any inappropriate language or imagery. Finally, I owned the CD and had easy access to the song.

As my students came into class that day, I had the song playing. Of course, I was flooded with questions about why I was listening to System of a Down. I began with a question of my own. Taking a poll, I asked how many people in the room listen to music. Every hand went up. Next, I asked how many people had heard of the band System of a Down. About half the class raised their hands. So with several puzzled looks on the faces of my eighth-graders, I let them know that we would be listening to some different kinds of music and analyzing the lyrics for figurative language and sound devices.

We had already briefly discussed figurative language and sound devices in our descriptive-writing unit, so students had a vague idea what to look for. Still, I handed out a list of the different figurative language and sound devices that they would encounter in our journey through music in English class. I played the song "Aerials" (SOAD, 2002) once for the class before handing them a copy of the lyrics. After listening to the song, we went through the lyrics and identified the figurative language and sound devices and discussed

what each meant. Students who had not heard of the band System of a Down at the beginning of class really liked the song choice; they were just as engaged as the students who had heard of the band and showed a great deal of interest at the beginning of class. An example of figurative language from the song "Aerials" by System of a Down follows:

> Life is a waterfall [Metaphor]
> We're one in the river
> And one again after the fall

For the independent practice part of the lesson, I switched the music genre. System of a Down is a pretty hard rock band, and it was difficult for me to find several songs that were school appropriate for this assignment. My husband and I are huge fans of the band Sister Hazel. They have many songs full of imagery, figurative language, and sound devices. Again, I owned the music, so my access was easy as was selecting songs that were school and lesson appropriate. The songs I chose from their album *Lift* (Sister Hazel, 2004) were "Firefly" and "The World Inside My Head." The songs I chose from their album *Chasing Daylight* (Sister Hazel, 2003) were "Life Got in the Way" and "Everybody." We repeated the guided practice portion of this lesson in that we listened to the song and then read through the lyrics. At this point, students were off to work with the figurative language and sound devices in their song.

To help alleviate some of the confusion as to what exactly the students were looking for, I went through each of the songs and found which figurative language and sound devices were included in the lyrics. I wrote out what the students were to identify, and they had to write the specific lyric. After they found what I asked them to identify, they had to find an additional three examples of figurative language, sound devices, or descriptive writing. I chose four songs because I have four English classes. This way, each class period would analyze a different song. As students worked, I let the Sister Hazel CD play. Of course, System of a Down fans wanted to listen to that CD, but I had to explain why we could not do that in school!

An example of a sound device in the song "The World Inside My Head" by Sister Hazel (2004) follows:

Where did everybody go without me?
So I like to fanta<u>size</u>
And watch the sun ri<u>se</u> like it's a big surpr<u>ise</u> [Consonance]

Student understanding of figurative language and sound devices seemed to improve following this lesson. Eighth-grade students at Goodrich Middle School posted high scores on the descriptive-writing portion of the Nebraska Statewide Writing Assessment!

Helpful Tips

There is a lot of music that a teacher could use for this assignment. Students could work independently, in pairs, or in groups. I found it helpful to start off with the hard rock song to get everyone's attention. An extension of this assignment could be for students to find their own songs with figurative language and sound devices to share with the class. Of course, the guideline would have to be for the songs to be school appropriate!

References

Sister Hazel. (2003). *Chasing daylight* [CD]. Atlanta, GA: Sixthman Records.
Sister Hazel. (2004). *Lift* [CD]. Atlanta, GA: Sixthman Records.
System of a Down. (2002). *Toxicity* [CD]. New York: Sony.

Teaching Social Studies

Overview, Chapters 30–36

30. **Dale Baumwoll**, a sixth-grade social studies teacher from Randolph, New Jersey, assesses his students' knowledge of various historical characters through role play. Dale hosts a party, invites his students to dress up as their favorite historical character, and awards students who stay in character throughout the party.

31. **Elizabeth Rees Gilbert**, a sixth- through eighth-grade teacher from Oakland, Maryland, connects with a class on a personal note by sharing with them her mother's experiences surviving the dust bowl. This introduction ties in to a unit of study on environmental change and how we impact our surroundings.

32. **Judy Lindauer**, a sixth-grade teacher from Ferdinand, Indiana, studies medieval Italy with her sixth-grade class. Judy's students research the medieval period and then express their newfound knowledge through a play they write and enact.

33. **Dale Baumwoll** uses the excitement of role play again in this lesson on how labor unions were formed. Playing the part of the uncaring factory manager, Dale has his students act out the role of the overworked factory workers—that is, until they strike!

34. **Steven M. Jacobs**, an eighth-grade earth science teacher from Dundee, Michigan, has his students simulate warring medieval powers by forming kingdoms and laying siege to each other's castles. The class learns about engineering of ancient weapons, managing money, and history in this fun unit.

35. **Spencer Bolejack**, an eighth-grade social studies teacher from Fletcher, North Carolina, teaches his students about the Mayflower

Compact by having them create their own government. Will your class break down to the point of secession and forming separate colonies, or will they have amazing democratic success? Try this lesson for a great hands-on learning experience.

36. **Spencer Bolejack** uses an interactive game to illustrate the effects of the natural habitat on human settlements. In this lesson on pirates off the North Carolinia coast, one blindfolded student acts as a ship and tries to locate the lighthouse (another student) without hitting any rocks on the way (more students!).

30. Historical Character Party

Dale Baumwoll
Randolph, New Jersey

Recommended Level: Grade 6

Overall Objective: Investigate historical characters from the years we have studied, and demonstrate knowledge on the characters by actively portraying the person in costume at a party and conversing with other historical guests.

Standards Met (New Jersey):

Social Studies: (6.1) All students will use historical thinking, problem solving, and research skills to maximize their understanding of civics, history, geography, and economics.

Materials Needed:

- Costumes
- Props and information on their character and other characters
- Teacher-provided refreshments (nothing too good to distract from the conversations at the party)
- Prizes for the person who stays in character and looks the most authentic

American history has so many characters to learn from. As a culminating activity, I ask my students to become one of their favorite historical characters and attend a party where they will meet many other people from history. Research, class discussion, and tips on party conversation help guide students through a successful portrayal and learning experience.

Students are directed to choose any historical character from the 100 years we have studied, 1860 through 1960. They have a week to make their final character choice. After making their choice, they sign up on a posted "guest list," so the class can see who is coming to the party. Students begin research to find 10 interesting items about their character using Internet, text, and library research. They must also pick 10 other characters on the guest list and research five bits of information in order to carry on intelligent conversations with other historical characters. Birth and death dates are discouraged as not being interesting facts for party conversation. Students are encouraged to find important or unique events in the person's life they are portraying and for the people they plan to converse with at the party to use for discussion.

Students must memorize the facts about the character they choose to portray. They can use note cards for reference when talking to the 10 other "party guests" they have researched. Students converse with one another while in character, asking pertinent questions of other guests and answering questions asked of them. We practice how to deal with a question they may get from a party guest that they have not researched and, therefore, don't have the answer to. Changing the subject and refocusing the attention to the other person are two strategies we work on so the conversation still flows smoothly. This is a great way to instill good communication skills and diplomacy. Parents are sent an invitation (see the example at the end of this article) to attend the historical character party and listen to interesting conversations. The parents don't dress up. In middle school, it's hard enough to get the kids excited about having their parents come into class; I don't think parents in costume would help! Many adolescent boys and girls appear to be hesitant about having their parents watch them in school, but they actually enjoy having them there at the party, and the parents *love* it even more. Whenever you can invite parents in, do it. They should see the wonderful things that go on in your classroom and how their children participate and learn.

When I introduce this activity, I give students a handout with directions for this activity (see the example at the end of this article). Students are told to dress the part, act the part, and become the character. After they have two weeks of research (mostly on their own with only a day or two in school devoted to library research), the party will take place in my classroom with a separate party for each class period. This activity is done during the last days of school, and there is no grade. You might think this would result in apathy from your students, but it is quite the opposite. I have never seen my kids so on task as they are in this fun and exciting activity. They are in constant conversation with other "guests," and I listen in, amazed at the information and understanding they have acquired on their character as well as others.

Even with the snacks and party atmosphere, the character portrayals are the first priority. I award prizes in each class party for the best portrayal. The requirements to win the top four prizes are staying in character from the moment they enter the room, using interesting and correct information when conversing with other characters, effective costumes, and knowledge of other characters at the party. I invite local businesses to offer great prizes because I want the kids to see how much I appreciate their efforts, especially in June. Prizes such as coupons for ice cream sundaes and free movie tickets might serve as incentives to keep them on task, but after doing this activity for the past few years, I can say with confidence that the prizes are just the icing on a very delicious cake! I award the prizes at the end of the class-period party, and the parents, students, and I feel very accomplished.

Helpful Tips

It is important to help the boys and girls choose a good character to portray by reminding them of the units you have studied all year. One way I keep these characters in their minds is by creating movie posters for each unit of study. The class casts the movie, which contains all of these historical characters. These "casting" assignments are given at the end of every two chapters, and the students are asked to come up with a celebrity (actor, athlete, politician, or any famous person) to play the part in our *American History* movie. Their decision to cast someone must be supported by giving me at least two character traits the celebrity has in common with the historical character.

The class votes on the suggestions and chooses someone for the part. I print out a photo of the person and paste it on the blank space next to the photo of the historical character on movie posters I have created for *American History: The Movie.* I have these movie posters displayed in my room all year. This is a great activity whether you plan a culminating party or not. It makes history fun and connects it to their lives and reminds students of the colorful and intriguing characters we have met along the way. It will guide them in their choices for their portrayal. Make sure the parents get your invitation to the historical character party. You could use your school communication system through e-mail, as well as sending a hard copy home with the students.

Who would you be?

We are studying 100 years of history, 1860 through 1960.

Choose a person you want to be from these 100 years. You can be someone famous, such as a president, celebrity, inventor, or business tycoon, *or* a regular person who lived during this time. Maybe you want to be your own ancestor, an Indian chief, a flapper, an immigrant, a reformer, a farmer, or a soldier.

How do you choose?

1. You like what that person did.

2. You think you could do important things like that person.

3. Life would be interesting as that person.

4. You like the time period.

5. You want to know more about that time period or that person.

(Continued)

(Continued)

What do you do?

1. Sign the guest list.

2. Research 10 important and *interesting* things about the person you've chosen and memorize them.

3. Check the guest list, because you must also be able to ask questions of the other guests. Research five things about 10 of the historical characters on the guest list so you can have conversations with them. You will meet them at a party and mingle! (You may use notes to refer to for this.)

Then . . . We will all gather for a party on _____ and have conversations with historical characters.

1. Please dress as your historical character (costumes, hats, props, or whatever you can arrange). Become the person!

2. You must be able to talk about yourself (as the historical person) using the facts you've researched.

Dear Parents,

We would like to invite you to a party. The guest list is amazing. We are gathering some of the most famous people from history together in the same room. Presidents, celebrities, inventors, army generals, famous activists, everyday soldiers, immigrants, and farmers from history will come together to talk about their lives and learn about each other.

We have been studying 100 years of American history this year, and there are so many important people we'd like to meet. The students have chosen the guest list, and we will have a classroom filled with interesting historical characters. Please join us for this once-in-a-lifetime gathering of people from the past. Refreshments will be served. The most important part of the party is the conversation.

You are invited to your child's class party:

TIME: _____to_____

DATE: _____

RSVP: dbaumwoll@rtnj.org (Or send a note to me in school.)

Looking forward to seeing you and having you see history come alive!

▨ 31. America's Dust Bowl

Elizabeth Rees Gilbert
Oakland, Maryland

Recommended Level: Grade 6

Overall Objective: Students will be able to evaluate the effects of drought and farming techniques (over-plowed and over-grazed land) on the lives of people who lived in America's dust bowl, 1931 through 1939.

Standards Met (Maryland):

Geography: (D.1) Analyze why and how people modify their natural environment and the impact of those modifications.

Materials Needed:

- "Out of the Dust" by Karen Hesse (1997), as many copies as you can gather for your class
- *Current Geography* text article "The Five Themes of Geography," particularly the Human-Environment Interaction section, which can be found by searching online. For example, see the following Web site: http://www.nationalgeographic.com/resources/ngo/education/themes.html.

- *Surviving the Dust Bowl* DVD (WGBH, 2007)
- Recording of, or lyrics to, "The Great Dust Storm" ("Dust Storm Disaster") by Woody Guthrie (1940)
- Bookmarked Web sites and hard copies of resources for leveled research on America's dust bowl, including excellent materials from the Library of Congress at http://memory.loc.gov/learn/lessons/99/dust/intro.html

Consider including these optional but helpful materials:

- *Children of the Dust Bowl: The True Story of the School at Weedpatch Camp* by Jerry Stanley (1992)
- "Dust Bowl" (2003), *Cobblestone Magazine*
- Related books from your local and school libraries

My mother, Sue Ann Lambert Rees, grew up in Muskogee, Oklahoma, during "the dust bowl days," as she and many others who lived through those years call it. I grew up hearing her stories of keeping a handkerchief handy, so she could wet it and cover her nose and mouth when the warning for an approaching dust storm sounded. She told of running home from school as fast as she could ahead of a storm or having to remain in school as one passed, completely enveloping her school and invading it with opaque clouds of brown and black powder. When Karen Hesse's epic poem "Out of the Dust" was published in 1997 and we read it together, I knew I needed to incorporate this marvelous literature in my Five Themes of Geography lessons to help students understand more fully the theme of human and environment interaction.

Steps

1. Read aloud pages 83 through 84, 31 through 33, and 162 through 167 from "Out of the Dust" (Hesse, 1997). Show an introductory clip from the *Surviving the Dust Bowl* (WGBH, 2007) DVD, or distribute a sampling of Internet materials you have gathered on this subject for students to preview.

2. Students brainstorm questions they have about weather conditions and farming techniques leading to dust storms ravaging the American Midwest, 1931 through 1939.

3. Group students, perhaps according to their multiple intelligences, and have them read and explore bookmarked Web sites; hard copies of Internet materials on America's dust bowl, 1931 through 1939; and related books from your local and school libraries.

4. With students, determine the rubric for the next activity.

5. Assign roles to group members for completing tasks. You could use roles used in literature circles:

 a. Director. Keep each person on track.
 b. Vocabulary keeper. Be sure keywords for the topic are explained in the presentation.
 c. Visualizer. Be sure graphics or other objects are used to convey the group's message.
 d. Summarizer. Help the group determine and present the main idea and supporting details for the presentation.
 e. Recorder. Record materials for the presentation, and so forth.

Or use the following roles if students are grouped according to their multiple intelligences:

 a. Writers. Research and write a new page of free-verse for "Out of the Dust" (Hesse, 1997).
 b. Artists or engineers. Research and create a two- or three-dimensional representation of a community's experience with the dust bowl.
 c. Musicians. Research and compose a new song or add a new verse to Woody Guthrie's (1940) song "The Great Dust Storm."
 d. Actors. Research and create a skit or vignette based on their readings.
 e. Naturalists. Research and present the short- and long-term effects of dust storms on living things and the environment.
 f. Mathematicians. Research and present the financial impact of America's worst ecological disaster.

6. Then, students use the Internet materials and books to prepare a five-minute presentation on the causes and effects of America's dust bowl.

7. Students share presentations, referring to their sources as necessary. Take photographs of students in the process of researching and presenting what they have learned.

8. Students return to their brainstorming questions. Which were answered and by which materials? Where could students find answers to questions still unanswered?

9. In different small groups, students discuss and record notes for a response to the following questions: What were causes and effects of America's dust bowl? and Does America or any other country face a similar disaster today? They are instructed to use examples from their own research and their classmates' presentations to explain their responses. Then, they share their own ideas about how we can keep from repeating these disasters.

HelpfulTips

Be sure to read "Out of the Dust" (Hesse, 1997) before sharing it with your students. Parts of it are stark and painful to read. Its reading level is 5.1, with an interest level of Grades 4 through 7, but my sixth- through eighth-graders respond to its resilient heroine every time we use it for this study. I introduce the book with this lesson and indicate that it has some parts that more sensitive readers might find hard to take. It's then available for further reading, as students feel they are ready for it. It can be read by a small group for a literature-circle study.

The other literature-circle groups can read the *Weedpatch Camp* (Stanley, 1992) book or the *Cobblestone* ("Dust Bowl," 2003) issue or view the *Surviving the Dust Bowl* (WGBH, 2007) DVD, if you were able to purchase it. Then, the literature-circle groups can divide into groups where all of the books read are represented. They can discuss the questions listed in Step 10 (What were causes and effects of America' dust bowl? and Does America or any other country face a similar disaster today?) and then share their own ideas about how we can keep from repeating these disasters.

As a culminating event, the whole class can record new questions their reading and discussion raised and view the *Surviving the Dust Bowl* (WGBH, 2007) DVD to find answers to their questions.

Help students make a bulletin board and share it with another class, school, and community. Students in the class who have emigrated from other countries could research and share similar ecological disasters that have occurred in their countries of origin. As your school year progresses, you may find that when your students discover more examples of human and environment interaction, you can return to the devastating example of America's dust bowl for a meaningful comparison of their causes and effects.

References

Dust bowl. (2003, April 1). *Cobblestone Magazine, 24*(4). Available from www.cobblestonepub.com

Guthrie, W. (1940). Dust storm disaster (The great dust storm). Available from http://www.woodyguthrie.org/Lyrics/Dust_Storm_Disaster.htm

Hesse, K. (1997). *Out of the dust.* New York: Scholastic.

Stanley, S. (1992). *Children of the dust bowl: The true story of the school at Weedpatch Camp.* New York: Crown.

WGBH. (2007). *Surviving the dust bowl* [DVD]. Available from www.pbs.org

▧ 32. Medieval Italy

Judy Lindauer
Ferdinand, Indiana

Recommended Level: Grade 6

Overall Objective: Students will explore some key figures, historic movements, and events of the medieval period from 400 CE to 1500 CE that contributed to the development of modern Europe.

Standards Met (Indiana):

History: (6.1.3) Medieval Period: 400 AD/CE–1500 AD/CE. Explain the continuation and contributions of the Eastern Roman Empire after the fall of the Western Roman Empire; (6.1.4) Medieval Period: 400 AD/CE–1500 AD/CE. Describe and explain the development and organization of political, cultural, social and economic systems in Europe and the Americas; (6.1.5) Medieval Period: 400 AD/CE–1500 AD/CE. Analyze the diverse points of view and interests of those involved in the Crusades and give examples of the changes brought about by the Crusades; (6.1.6) Medieval Period: 400 AD/CE–1500 AD/CE. Examine the importance of trade routes and trace the rise of cultural centers and trade cities in Europe and Mesoamerica; (6.1.7) Medieval Period: 400 AD/CE–1500 AD/CE. Explain the effects of the Black Death, or bubonic plague, along with economic, environmental and social factors that led to the decline of medieval society; (6.1.8) Medieval Period: 400 AD/CE–1500 AD/CE. Compare the diverse perspectives, ideas, interests and people that brought about the Renaissance in Europe; (6.1.9) Medieval Period: 400 AD/CE–1500 AD/CE. Analyze the interconnections of people, places and events in the economic, scientific and cultural exchanges of the European Renaissance that led to the Scientific Revolution, voyages of discovery and imperial conquest.

Language Arts: (6.7.1) Comprehension; (6.7.4) Organization and Delivery of Oral Communication; (6.7.5) Emphasize important points to assist the listener in following the main ideas and concepts; (6.7.6) Support opinions with researched, documented evidence and with visual or media displays that use appropriate technology; (6.7.7) Use effective timing, volume, tone, and alignment of hand and body gestures to sustain audience interest and attention; (6.7.10) Speaking Applications.

Materials Needed:

- Props for the play
- Computer and book resources
- Information about the period
- *A Medieval Feast* by Aliki (1983)

- Web sites
 - ❖ www.suelebeau.com
 - ❖ www.medievality.com
 - ❖ www.homeschooling .about.com

The Medieval Italy project consists of intense research of the medieval period followed by a play written by the students. The students are given some instructions to follow concerning character, setting, and so forth, and the project culminates with a medieval feast.

Phase 1 of the project begins with a five- to seven-day period of research and discussion of medieval Europe concerning feudalism, the power of the church and the spread of Christianity, royalty, everyday life, learning, the arts, craftsmanship, bubonic plague or Black Death, changes brought about by the Crusades, trade routes and cultural cities, scientific inquiry, and finally the move toward humanism in the late 1500s. The focus is on people who helped enact this change such as Leonardo da Vinci, Michelangelo, Nicolaus Copernicus, William Shakespeare, and Galileo Galilei. Sometimes, I invite a guest speaker to demonstrate blacksmithing or how to make stained glass.

After a solid foundation of knowledge of the time period and its people have been established, we begin Phase 2, which is working on creating the play. I create a basic outline consisting of two settings, the medieval village of Pialto (I made up this name) and medieval Florence. The students choose the cast of which they will become a part. The Pialto cast consists of roughly one-half of the class as does the Florence cast. I create character suggestions for Pialto such as a blacksmith, farmer, priest, gentry, stained-glass artisan, baker, one to two children in a family, and so on. For Florence, the cast might include a merchant, Leonardo da Vinci, a statesman, teacher, doctor, shopkeeper, trader or explorer, one to two children in a family, and more.

The point is, all of these roles are merely suggestions for the students to set the wheels of thought in motion. Hopefully, they will expand on and revise my ideas as they become more involved with creating the plot. The village cast and the city cast will be working independently of each other for a portion of the time and together for part of the time. The stained-glass artisan and his family go to the city from

time to time to sell his goods to a merchant. The artisan's family and the merchant's family become friends and thus enable the comparison of village life versus city life. The characters' names, personalities, plot, and the rest will be a creation of the students' imaginations.

Costumes generally are creative, and we get help from some Web sites and books we have in the classroom. We usually have at least one or two artists in the class who spearhead the props department. I generally take the role of the guide on the side. There are times when students need a little help with plot ideas to build suspense, or I may need to be the mediator between the two casts. The students love the freedom to create and make the play their own. I emphasize the point to keep the events as close to the period as possible to portray life in medieval Italy. The play usually lasts from 20 to 30 minutes.

Finally, Phase 3 is the medieval feast. We study the foods that were commonly eaten during this time period. I have a book titled *The Medieval Feast* (Aliki, 1983), which is helpful, as well as some Web sites. The fare is simple. It usually consists of fresh or cooked fruits and vegetables, beef and chicken soups, breads, and usually a pudding dessert. The students are willing to bring something in for the feast. After the performance of the play, we celebrate the culmination of another successful learning project.

Reference

Aliki. (1983). *A medieval feast.* New York: HarperCollins.

33. The Workforce

Dale Baumwoll
Randolph, New Jersey

Recommended Level: Grade 6

Overall Objective: Students will be able to identify the problems that the workforce faced in factories and discover how unions created solutions for American workers in the 1890s by experiencing the atmosphere of a factory in that time period.

Standards Met (New Jersey):

Social Studies: (6.1) All students will use historical thinking, problem solving, and research skills to maximize their understanding of civics, history, geography, and economics.

Materials Needed:

- Contract
- Unlined paper
- Pencils
- Pencil sharpener
- Rulers
- "What were they thinking?" activity pictures

As part of our historical study of robber barons and big business in the late 1800s to the early 1900s, students learn about the development of unions and how they helped average American workers have a voice, resulting in fair, safe treatment in the workplace.

Middle school teachers are aware that their students' social lives are more important to them than what they learn in school. It is our responsibility to find the connection between our subject area and their lives. This is difficult to do, especially when the curriculum includes reconstruction, reformers, and world wars that don't seem to have anything to do with the life of a 12-year-old. When there seems to be no relevance, we have to find it. When we are studying reformers, people who make things better, we can create projects where students can find things in their school or community that need to be improved, and the 12-year-olds in our classrooms can become reformers. When we can't make a connection for them, we can make it fun or real. In this lesson, we're going to make it fun and real. When you can do both, you are making a connection they will remember.

Simulations are a very effective strategy to help students understand by doing. In this case, I took a piece of the curriculum that would normally be boring and hard to relate to and helped students experience it rather than read or write about it. In the chapter on big business, we teach about robber barons, monopolies, corruption, new inventions, and the workforce. In the section on the workforce, we focus on the importance of unions. Students need to understand the difficult conditions that workers faced in the factories. We teach them about the function of unions and how these organizations help give a voice to the workers, resulting in the power of the many gaining better hours, pay, and treatment. I create a

simulated factory right in my classroom using a fictional company called The Paper Lines Corporation.

It is a company that makes lined paper by hand! It was important for me to create a company where the work would be tedious, so the students would understand the monotony of factory work. Students do some prereading on factory conditions during the late 1800s. The day before the factory simulation, the unfair and dangerous treatment of the mostly immigrant workers is discussed and connected to the unfeeling owners and managers of these businesses. Then, the students are given complete directions and instructions. They are told they are members of the AFL, American Federation of Labor, a union organization for skilled workers only. Their union will help them make changes if working conditions are poor. The contract (see the example at the end of this article) for their salary and benefits, or lack thereof, is also given to them the day before beginning the simulation.

The Day of the Lesson

The classroom becomes a simulated factory. The room is cold with poor lighting, and a very demanding manager keeps the workers on task and expects perfect products. I play the mean manager; it is important for the teacher to stay in character the entire time of the simulation. Workers are required to work in silence and report to the manager for approval when each piece of lined paper is completed. Of course, the manager will not accept shoddy work and firing is always a threat. They will be told that there are plenty of immigrants waiting to take their job in a minute if they don't follow the rules of the factory. Factual information like this is given by the manager in the form of reprimands throughout the lesson. Another example of facts presented during the simulation is that they are members of the AFL, which only accepts skilled workers so they better prove they have the skills to do a good job!

In this fictitious company, The Paper Lines Corporation, the women measure the blank paper in half-inch sections with a pencil mark on each side of the blank paper. The men draw the lines to create lined paper, and the children sharpen the pencils (see the contract at the end of this article). Students work at their assigned jobs silently for the entire period in the uncomfortable conditions. The students are on task all period and completely silent, but smiling and obviously enjoying the activity immensely. At the end of the period, the workers (students) are

directed to plan to strike the next day for better working conditions. This will be part of their homework assignment. They will use the contracts they have each received to decide what kind of conditions they won't tolerate anymore and what their demands will be.

For homework, the students fill in thought bubbles of factory workers on a "What were they thinking?" picture with appropriate information. The "What were they thinking?" activity is something I use in many lessons as a closure activity. They know the expectations of this activity after it is introduced at the beginning of the year. They have to use facts within their thought bubbles to show understanding of the person's point of view. If students can tell you what someone is thinking, they understand it! Students also create strike signs to display during their strike in class the next day. These signs must indicate their specific demands for better working conditions. In class the next day, students will be directed to march around the room showing their signs. The manager (teacher) will give in by stopping the strike and telling the workers (students) they can begin working on a list of demands. They present these demands, and the manager (teacher) writes them on the board and begins to compromise with the workers. The Paper Lines Corporation creates a new contract. Students see how compromise and unions work.

Helpful Tips

The dramatic piece of the simulation presented in this lesson is a key component to making it "fun." Middle school kids love to be entertained, and they love when their teacher acts silly. So act silly sometimes and get your students to act silly. When you plan the silliness, your class will be on task and your students will pay attention!

Simulations are not always easy to do, but making your lessons relevant and real is easier than you think. Boys and girls usually think American history has nothing to do with their lives, but it does. Remind students, while you are focusing on historical events, that there were 11- and 12-year-olds living their lives during all of these time periods in history. Explain how in 100 years boys and girls may study the Iraq War. The books may not address the fact

(Continued)

(Continued)

that 11- and 12-year-olds were just living regular lives during the war. Children were texting friends, playing video games, and enjoying the newest cereal flavors for breakfast. Have your students research what kinds of toys, food, inventions, sports, and so on were introduced to America at the time of your lesson.

For example, when I study the movement west, homestead farmers, and the Great Plains Indians in the years from 1860 through 1890, the kids find out in their Internet searches that Coca-Cola, Dr. Pepper, Campbell's soup, and ice cream sundaes were introduced to Americans. We can now connect to the people of the time eating and drinking the same things we are eating and drinking today. Football, baseball, and basketball were also organized as spectator sports during these same years. All kids can connect to playing or watching one of these sports. When I remind them that there were families drinking Coca-Cola and playing ball behind their houses while all the events of history in our textbook were happening, it makes it real to them and not so prehistoric.

When I present a "What were they thinking?" lesson, I wear a headband with a big thought bubble on my head that says, "What were they thinking?" I look silly, and the kids pay attention and do the activity with interest. They even look forward to it!

Paper Lines Corporation Contract
Established 1880

Salary Guide

	Job	Pay	Hours/Days
Men	Draw lines	$5 per week	7 a.m. to 7 p.m./Monday through Saturday
Women	Measure lines	$3 per week	7 a.m. to 7 p.m./Monday through Saturday
Children	Sharpen pencils	$2 per week	7 a.m. to 7 p.m./Monday through Saturday

Contract Agreement

1. Workers must be on the job 12 hours per day, six days per week.

2. There are no paid sick days.

3. All employees may take one week off without pay.

4. Management is not responsible for medical bills resulting from job-related injuries or illness.

5. Weekly wages are set at $5 for men, $3 for women, and $2 for children.

Supplies

Men: plain measured paper, ruler, and pencils

Women: plain paper, pencils, and ruler

Children: pencils and pencil sharpener

If workers are not satisfied with this contract or these working conditions, they may decide to strike. The workers should have suggestions for the management to improve their working conditions and to modify the contract to their specifications.

Suggestions from your AFL union representative follow:

Higher wages	More time off with pay
Lessen the child labor	Dining and recreational facilities
Fewer hours per day	
Medical benefits for job-related injuries	Adequate heating and lighting

⧈ 34. War!

Steven M. Jacobs
Dundee, Michigan

Recommended Level: Grades 6–7

Overall Objective: The goal of this project is to lay siege to neighboring lands and gain the riches of a conquering noble. Your students will be excited to learn the history of the dark days of Europe, develop their engineering skills, learn about personal and business economics, and grasp the scientific concept of simple machines.

Standards Met:

National

> *Social Studies:* (NSS-WH.5–12.5 ERA 5) Intensified Hemispheric Interactions, 1000–1500 CE: Students should understand the historic redefining of European society and culture, 1000–1300 CE; (NT.K–12.2) Social, Ethical, and Human Issues: Students should understand the ethical, cultural, and societal issues related to technology; (NSS-G.K–12.4) Human Systems: Students should understand how the forces of cooperation and conflict among people influence the division and control of Earth's surface; (NSS-EC.5–8.1) Scarcity: Students should understand that scarcity is the condition of not being able to have all of the goods and services that one wants. It exists because human wants for goods and services exceed the quantity of goods and services that can be produced using all available resources; (NSS-EC.5–8.7) Markets: Price and Quantity Determination: Students should understand that market prices are determined through the buying and selling decisions made by buyers and sellers; Students should understand that relative prices refers to the price of one good or service compared to the prices of other goods and services. Relative prices are the basic measures of the relative scarcity of products when prices are set by market forces (supply and demand).

Michigan

> *Science:* (P.EN.06.11) Identify kinetic or potential energy in every-day situations (e.g., stretched rubber band, objects in motion, ball on a hill, and food energy); (P.EN.06.12) Demonstrate the transformation between potential and kinetic energy in simple mechanical systems (e.g., roller coasters and pendulums).
>
> *Social Studies:* (7-E1.1) Explain the role of incentives in different economic systems (e.g., acquiring money, profit, goods, wanting to avoid loss, position in society, and job placement); (7-G2.2.2) Explain that communities are affected positively or negatively by changes in technology (e.g., increased manufacturing resulting in rural to urban migration in China, increased farming of fish, hydro-electric power generation at Three Gorges, and pollution resulting from increased manufacturing and automobiles); (7-H1.4.1) Describe and use cultural institutions to study an era and a region (e.g., political, economic, religion or belief, science and technology, written language, education, and family).

Materials Needed:

- Paperclips
- Masking tape
- Toothpicks
- Rubber bands
- Straws
- Toilet paper
- Projectiles
- Protective goggles
- Game pieces
- Animal or human action figures
- Castle components: Milk cartons, dominos, water bottles

This project is the perfect opportunity for your students to develop their understanding of the medieval period. It is an interdisciplinary lesson that focuses on the "six simple machines" and the history of the Middle Ages.

Can you create siege weapons with drinking straws and masking tape? The answer that your students will be shouting at the end of this lesson is "yes!" The students will learn all about medieval Europe in this engaging lesson. I always start the lesson by showing a movie clip of siege weapons and refreshing the students' memories in regard to the six simple machines. The students are divided into groups to complete the construction. Each

student receives a job that fits their ability. The jobs include the engineer who draws the blueprints of the siege machine, the accountant who budgets group money, the scribe who writes a decree on why they will attack another group's lands, and the noble lord who keeps the process organized. After explaining the rules of the project, the students receive classroom money to buy supplies. This part is very important to the economic portion of the simulation. The students are limited to purchasing supplies twice. That means that they must think ahead and spend their money wisely. They also have a set time to complete the building of their weapons. This generally takes four hours of classroom build time. Continually, to help the students understand supply and demand, the price of the items that the students are allowed to purchase fluctuates day by day based on the supply available and the demand of the students. I simply write the prices on the chalkboard. Your students will comprehend the concept when prices go up overnight. Furthermore, I allow the students to bring in materials to be sold for classroom money. This helps with having sufficient materials and demonstrating how supply can make prices fluctuate.

After the students have made sketches of their siege weapon, they are allowed to build their machine. My students generally find that engineering a working machine on paper is challenging. This really forces the students to use higher-level reasoning skills and their spatial awareness. Drawing the blueprints for the siege weapon is an integral part of the preparation to purchase materials. The students then begin the process of constructing their siege weapons. The students are only allowed to buy drinking straws, toothpicks, paperclips, rubber bands, and masking tape. With these materials, your students will be able to create offensive and defensive devices. The items that are used for their siege attacks are trebuchets, ballistae, catapults, onagers, battering rams, barriers, and portcullises. The siege weapons constructed by your students can be moderately powerful. I recommend that you use soft projectiles with some weight. It is also advisable that your students use protective eyewear. In some cases, the students may decide to create a ballista. This device shoots projectiles shaped like an arrow. The bolts (projectiles) that my students use are fashioned from unsharpened pencils with a large blunted toilet paper end. A stuffed drinking straw with a blunted end would also work.

On the final day of the project, the students give a written decree to another noble lord and wage war against his estate. The castles are made from empty school milk containers. Points are awarded for knocking

down containers and other destructive means. The students should not stand behind the castle or in the firing range when volleys are being launched. As the teacher, you should be prepared for some groups to have made nonworking siege devices. In the end, the overall conquering team wins the praise of the king and vast riches.

HelpfulTips

I often pay, with classroom money, a student to work the store during the hour.

Lay Siege and Storm the Castle

Rules of Engagement

Military conflicts during medieval times were based around one side laying siege to their opponents' castle or estate. Properly defended castles were always very hard to conquer. To gain more lands, wealth, and power, the militaries would build siege machines to destroy their opponents' defenses and gain access to the kingdom.

Offensive Siege Weapons
- Trebuchet
- Ballista
- Catapult
- Onager
- Small weapons (bow and arrow made from a paperclip and rubber band)
- Battering ram (has to move on its own power)

Defensive Weapons
- Walls
- Barriers (toothpicks would work well)
- Portcullises

(Continued)

(Continued)

Projectiles

Projectiles cannot be retrieved after they have been fired.

- Bolt = $10
- Bolder projectile = $1
- Diseased carcass = $10

Cost of Items

Each team will receive $400 from the king.

- Beam (pencil) = $50 (optional)
- Logs (straws) = $3 each
- Rope (rubber bands) = $10 each
- Iron (paperclips) = $.50 each
- Sticks (toothpicks) = $.10 each
- Twine = $5 for 1 foot (optional)
- Tape

 ❖ Every group will get two tables worth of tape from the king.
 ❖ Extra tape = $25

Note: Costs are subject to change based on supply and demand.

Mission

Your task is to take as many lands as you can. You will do battle with other nobles to take their manors. Before you can engage in battle, you must create siege weapons to knock down walls or destroy their castles. You should also think about defensive items to protect your castle from attack.

Your siege weapon will launch items of your choice at a castle barrier. The siege weapons must be at least six feet from the castle. You can make as many offensive and defensive weapons as you wish. You will get seven offensive volleys to lay siege to your opponent's castle. This means that the more siege weapons you make, the more projectiles you're able to launch on one volley. However, the

more siege weapons you make, the more inaccurate and lacking in power they will be. It's your task to optimize your limited supplies.

Setup

Nobles will have their army move the siege machines into place six feet from the opposing castle.

Armies will have seven allotted volleys.

The projectiles used are the choice of the individual noble but must be purchased from the king.

Points

40 points for each game piece knocked off the table (Game pieces represent villagers' homes; many civilians would have taken shelter during the siege.)

30 points for each water bottle knocked down (Water bottles represent the towers of the castle, which were strategic lookouts and defensive strongholds.)

30 points for correctly stating which simple machine(s) your siege weapon is demonstrating (The six simple machines are lever, inclined plane, wheel and axel, screw, wedge, and pulley.)

20 points for every small rectangular block knocked flat (Blocks, such as dominos, represent the doors, the weakest and most vulnerable part of the castle.)

10 points for every milk carton knocked down (Milk cartons represent the castle walls.)

60 possible points for decomposing or diseased carcasses

Any team that shoots animal or human action figures can gain points. If a decomposing or diseased carcass is shot into the village, the team must wait two volleys to find out what their points will be (that means a team can only use this tactic two times).

(Continued)

(Continued)

After the disease takes a foothold, dice will be rolled to find the points achieved. The number rolled will be multiplied by 10.

Materials List Sheet

Name of Material	Quantity	Multiply	Individual Item Cost	Equals	Individual Total Cost
		×		=	
		×		=	
		×		=	
		×		=	
		×		=	
		×		=	
		×		=	

The accountant needs to complete this sheet based on the materials listed on the architect's drawings.

Final Cost _____

1. Add all of the "Individual Total Costs" to get your "Final Cost" for the materials you are purchasing.

2. Remember, you may use only the money that is allotted to your group.

Name of Material	Quantity	Multiply	Individual Item Cost	Equals	Individual Total Cost
		×		=	
		×		=	
		×		=	
		×		=	

Name of Material	Quantity	Multiply	Individual Item Cost	Equals	Individual Total Cost
		×		=	
		×		=	
		×		=	

Complete this materials list if you buy materials for a second time. You may only buy materials two times.

Final Cost _____

1. Add all of the "Individual Total Costs" to get your "Final Cost" for the materials you are purchasing.

2. Remember, you may use only the money that is allotted to your group.

35. The Mayflower Compact

Spencer Bolejack
Fletcher, North Carolina

Recommended Level: Grade 8

Overall Objective: Students will describe the factors that led to the founding of the American colonies, including religious persecution, economic opportunity, adventure, and forced migration.

Standards Met (North Carolina):

Social Studies: (1.03) Compare and contrast the relative importance of differing economic, geographic, religious, and political motives for European exploration; (1.05) Describe the factors that led to the founding and settlement of the American colonies including religious persecution, economic opportunity, adventure, and forced migration.

Materials Needed:

- Whiteboard or overhead for notes and sketches
- Digital camera

Introduction

One thing that makes history come alive for students is being able to put themselves in the shoes of those we study. When we combine the sedentary nature of most classes with a 70-minute period, the need leaps out for kids to learn, in part, by doing! The Mayflower Compact was our nation's first governing document and was forged while on board a ship, hence the name.

Main Ideas

Colonists had to develop self-governance from the beginning. This promised great freedom but risked peril as well. Human nature makes compromise difficult, and compromise is a political reality. Agreement is difficult, especially under time and physical constraints (such as on board a ship!). Democratic systems have faults and autocratic systems have more faults. Ultimately, self-governance led to a spirit of independence that developed until the Revolutionary War centuries later.

Class

I begin this lesson by covering the key players involved and questioning students as to what challenges would exist for the authors of such a document. I ask students to imagine being on board for months, arriving in a new and strange land. Why do we need governance in the first place? What pressures would tax our emotions, our health, and our relationships? Taking this information, I create tables on the board listing student answers. Students quickly sketch a sailing ship in their notes and headline it with Mayflower Compact. Answers from our discussion table on the board are woven in around the ship in the sails, the hull, and even the sea. This creates a visual connection for the material. Key figures and dates are written in the border area—colors are

cool! Next, I ask critical questions about leadership, jealousy, and division of labor:

Is there any danger in allowing one person to make all of the decisions?

Should people who don't help or work as much have an equal say in decisions?

How would you deal with dissenters, or those who broke away from the main group with alternative ideas or behavior?

Is there a mediation process for disagreements; why might division lead to failure?

And finally, how could failure mean death for colonists in a world new to them?

One element of citizenship that comes into play here is to get my class to understand that even with all of our faults and frailties as a country, it is remarkable that we have adapted and survived all these years, that elections take place, and that we have a functioning government that does very well to represent different voices. I want them to recognize the extreme challenges to creating a system of government out of necessity and implementing it. Finally, we move into the "do it" stage. I put up an overhead with a rubric that describes what I expect. The class must create five rules that everyone agrees on and which are appropriate for school. The class must have a leader and four elders, who are like officers, to interact with everyone else. Everyone in the class will have a job that they are willing to do. By the time class ends, the document must be written and turned into me. The classes will be in competition for A+, A, B+, and B grades.

Grading is based on efficiency, how quickly the goal was completed. Also considered are problem solving, handling disagreements, and written completion. You could make your own guideline here. The number one question is, "Would you survive as a colony?" I then turn the class over to the students without any additional guidance whatsoever and remind them that the clock is ticking. I watch with great amusement as people try to make themselves leaders, girls turn against boys and vice versa, elections are held, or not, and kids argue over jobs. The difference I have witnessed between classes sums up almost every political philosophy known! Dictators arise and get things done but leave many frustrated. Fair-minded

people argue until they are out of time. Representative systems showcase quick thinking and mutinies subdue poor leaders.

The follow-up activity is important and usually happens the next day. I highlight which class earned, in order, the various grades and why. Then, students give feedback on what worked and didn't work. I've seen classes break down to the point of secession and the forming of separate colonies, and I've seen amazing democratic success. I close by tying it back into the Mayflower Compact and comparing our predictions of challenges to what happened. I like to ask whether religion or social customs of the day would change things a bit for the process and congratulate each class on their efforts. Be sure to take pictures. What a great time it is to present a slide show at year's end with the uproar that was "The Mayflower Compact"!

36. Graveyard of the Atlantic

Spencer Bolejack
Fletcher, North Carolina

Recommended Level: Grade 8

Overall Objective: Introduce students to how geography affected the development of the Atlantic coast.

Standards Met (North Carolina):

Social Studies: (1.01) Assess the impact of geography on settlement and development of the colonies; (1.02) Determine the relative importance of economic motives for exploration and development.

Materials Needed:

- Whiteboard or overhead projector
- Blindfold materials

- Safe outdoor space (This could be indoors, but getting outside for a moment is just golden.)

Deepwater ports are essential for trade and growth. Areas lacking deepwater ports not only developed more slowly but were home to

pirates and miscreants, who used shifting sands and tides to hide out and evade larger vessels. Lighthouses performed an essential function in warning or guiding ships arriving from the Atlantic Ocean. Erosion happened. Pirates were devious!

Class

Students arrive to class with essential questions written on the board. How did geography affect the development of the Atlantic coast? Why is North Carolina known as the graveyard of the Atlantic? They use the first few minutes to give both questions their best shot, after which I hear what they have to say. I refrain from giving corrections or decisive answers and will revisit the questions in the last few minutes of class to see whether the students are more on target as an assessment of the process. I have a sketch on the board of a shallow beachhead with a sailing vessel anchored far off shore. The class generates information on how materials would be ferried back and forth from the main ship and what difficulties would exist for sailors. I compare this with a drawing or sketch on the board of a deepwater port where large vessels can dock directly to an offloading station. I ask them questions about how this would ease the flow of goods and people.

At this point, it's neat to hear whether anyone has been to the ocean and whether they visited a shallow "surf style" shore or a port with ships around. When students are asked to describe the various surroundings, ports are inevitably depicted as more built up with buildings and business, and the surf beaches tend to be portrayed as more residential or visitor oriented with open sand beaches for people to enjoy. I then ask students to line up outside my door (as we have practiced!) and head outside. Once in a safe location outside, I take the following volunteers: one person as a "ship" and one person as a "lighthouse." The ship gets blindfolded and stands to one side. The lighthouse begins a slow clapping on the other side. In between the two, the rest of the class sit around acting like such things as sandbars, shoals, and rocks. Directly toward the lighthouse is an open channel. Now the ship has to listen to the lighthouse and navigate safely through by taking small steps. Bumping into anyone means a crash, sinking, drowning, and general doom. Making it to the lighthouse means wealth and fame!

After doing this once or twice, I add a ship and have the sands shift so new channels are created. After doing it once or twice more, I let a pirate sneak in and become a false lighthouse—the pirate intends to lead a ship astray and crash them into the rocks! The ships must determine which lighthouse is correct by listening carefully. Upon returning to the classroom, I tell them that North Carolina had such shifting sands and channels that dozens upon dozens of boats met their end, giving rise to such names as Cape Fear. This is why Carolina coasts are considered a "graveyard."

As a final note, I discuss erosion with the class. It's great if you have a few satellite pictures showing how much a hurricane can change a seacoast. Connecting this to the dangers of sea travel in the days before aerial imagery is effective. My textbook has a section on how much money has been spent—building roads into the sea and bridges over solid ground—trying to anchor down the outer banks. I give them a minute to correct their original essential-question answers if they need to and have them turn these in as they leave. This becomes common assessment data shared with the department schoolwide. Fun and proficiency, you can't beat that!

Helpful Tips

If you need a few extra minutes, add a short discussion on climate change. How would climate change affect erosion and seaboard landscapes? What might this mean for shipping and trade? This is a neat way to introduce climate issues in a way that connects across political boundaries.

If your class is on a 90-minute format and you would like to really catch their attention outside with some "wow" material, find hand-held plastic Fresnel lenses on the Internet. These cheap ($.05 to $1), card-sized plastic lenses are the same design that was invented by a French fellow for light amplification in lighthouses. It's essentially a flat magnifying lens. You could talk about how lighthouses generated strong signals before modern technology and then show how quickly the lens can heat up a small leaf or generate smoke on a piece of bark. Obvious safety considerations should be made, but it's sure to send your kids home talking about social studies!

PART IV

Music, Art, and Physical Education

Celebrating
Music and Art

Overview, Chapters 37–40

37. **Denese Odegaard**, a string specialist from Fargo, North Dakota, suggests ways to evaluate student performance in orchestra, band, or choir according to the national music standards. Denese provides rubrics for grading, as well as sample activities and assessments.

38. **Amy K. Dean**, an art teacher from Fort Mill, South Carolina, helps her students create their own comics in conjunction with a lesson on the history of comics and the study of Doug Marlette in this 13-day unit. Amy's students try their hands at writing, drawing, and coloring comics, and at the end of the unit, Amy encourages them to submit the finished product to their school newspaper for publication.

39. **Gayle Gruber Hegerich**, a fine arts teacher from Brick, New Jersey, teaches students about the basics of color theory with colored icing on vanilla wafers. Gayle's students love this project because at the end of the period they eat their completed color wheels.

40. **Gayle Gruber Hegerich** introduces her students to the Chinese zodiac in this lesson on illustration. Students explore the cultural significance of the different animals of the zodiac and get to draw their zodiac sign.

▧ 37. Successful Music Through the Use of Standards and Assessment

Denese Odegaard
Fargo, North Dakota

Recommended Level: Grades 6–8

Objective: Organize music class using a standards-based curriculum and assessments.

Nothing motivates a student to want to learn more than an organized learning atmosphere using standards-based curriculum and assessments.

Begin by looking at what you already do as a teacher. How do your activities fit with the national standards? Do these activities cover many standards, or can you expand them to include more standards? How do you assess without interrupting class?

Let's look at an activity you may already be using. In a beginning instrumental class, students have learned a new set of notes through a song, exercise, or piece. That covers one standard. Below, you can see where using more standards not only helps students retain the notes better, but also offers a variety of activities that are assessable for grading and do not interrupt class for long periods of time.

Standard 5: Students Reading and Notating Music

Activity. Students learn a set of new notes through exercises, songs, or pieces.

Assessment. Teacher evaluates the accuracy of note reading by having the students say, play, or sing the letter names of a measure, line of an exercise, or phrase of a piece.

Standard 3: Students Improvising Melodies, Variations, and Accompaniments

Activity. Students improvise that set of new notes within a set rhythmic and beat structure, such as two beats to a measure using quarter and eighth notes.

Assessment. Teacher evaluates the use of these newly learned notes in a set rhythmic and beat structure during improvisation.

Standard 4: Students Composing and
Arranging Music With Specified Guidelines

Activity. Students write a composition using those new notes and a computer composition program to make a final copy for their own performance, performance by others, and for their portfolio.

Assessment. Teacher checks for evidence of correct note placement within the given rhythmic structure.

Standard 2: Students Performing on Instruments,
Alone and With Others, a Varied Repertoire of Music

Activity. Students play their own composition for each other and record it for their portfolio. Students can play each other's compositions, or you can use them for warm-ups in a group setting.

Assessment. Teacher evaluates the student on note accuracy, tone, intonation, and willingness to improve the performance or recording. Allow students to perform or record compositions again if they are not satisfied.

Standard 7: Students Evaluating Music and Music Performances

Activity. Students evaluate their own performance of the composition while listening to their recorded performance, or other students evaluate the live performance of the composition.

Assessment. Teacher checks on comments made verbally or in writing, which should include what was done well and what could be improved upon. Students will become critical listeners in their own practice and in the performance of others through this procedure.

This model uses five standards, two forms of technology, and five assessments, and reinforces these new note names in varying ways that do not interrupt the flow of the class while making class more interesting. Assessments are short whether they are done in class as students do the activities or out of class viewing compositions and evaluations. There are two pieces of evidence of student learning for the portfolio: the computerized composition copy and the recorded performance of the composition.

Basic rubrics can be written—adapting the statements for elementary, middle, and high school—for band, orchestra, general music, and choir. Rubrics can be designed to assess skills (improvisation, composition, note reading, listening, and evaluation) and relationships to other classes, arts, and culture. Standard 1 (singing) and Standard 2 (instrumental) are going to be used and assessed more. That does not mean you don't have to use and assess the other standards.

Once you have expanded the activities already in place, begin to research new ideas to incorporate into teaching. There are many resources, including books on the market and information on the Internet, with standards-based music activities. While studying the standards, think how standards can be "chunked" differently into one unit of teaching as shown in the example above. Assessments should be short and done in a portion of a class period. It is always nice to have extra activities for the students who are done with their assessment, so there will be fewer interruptions as you finish with the other students. Remember, it is not necessary to evaluate a whole piece to get the results of a phrase or line.

You now have a bank of standards-based activities and can begin to look at the materials used in your classroom to sequence them in a manner that will make music unfold for the student. In my junior high orchestra sectional class, I use three method books: one covering technique, one on solo literature, and one addressing ensemble playing. Students learn most effectively with repetition, so I sequence my material by key signature, then difficulty of rhythms, and then other concepts such as articulation, dynamics, style, or history. This way, they stay in the same key for a long period of time, the rhythm difficulty is graduated, and I can introduce other concepts when appropriate within each key throughout the year.

Make a spreadsheet with the following headings across the top of the page to sequence material and to facilitate thinking of ideas to incorporate into the lesson:

Book, Page Number, Piece, Key Signature, Notes, Rhythm, Articulation, Form, Listening, Evaluating, Ensemble, Composition, Transposition, Improvisation, History, Culture, Other Arts

Fill in all of the information, and add activities to do with pieces or exercises that will enhance the curriculum and meet the standards.

Curriculum mapping is becoming an important part of education because it organizes what concepts a student learns and when. Curriculum written following the standards for each level (fourth grade, eighth grade, and twelfth grade) will stay within the boundaries of what is expected at each grade level. This way, too much time spent on a concept that is not appropriate at that level will not happen. A prime example of this is that many elementary teachers teach the dinosaur unit because it is fun. This means that the students may have that same unit four to six times in elementary school when they should only have that unit once.

Another reason to follow a sequential curriculum using the standards is that, as our society becomes more transitory, students will receive a better education if standards are met in all school districts they attend. Often, students transfer to other schools within the district: Even if curriculum is not mapped, following a districtwide curriculum written by grade level allows students to learn what is expected at any school.

Let us address assessment. Most common negative statements include how much time is consumed and how intrusive assessments are in the classroom. There are many different ways to assess both formally and informally. The fact that elementary teachers have large numbers of students or high school instructors teach large ensembles introduces challenges. The key is to invent short, quick assessments that get right to the point.

It is best to write assessments, such as rubrics, that can be used to assess a variety of criteria (for multiple levels) using the same tool by varying material and level of difficulty. It is not always necessary to access each criterion on the rubric. A multifaceted rubric can be given

to the students for reference with the teacher notifying the students which criteria will be assessed before each assessment. Below is an example of two criteria used on a vocal performance rubric:

List of criteria	Level 4	Level 3	Level 2	Level 1
1. Notes	Student sings all notes with precision and fluency in the proper steady tempo.	Student sings all notes accurately in a steady tempo.	Student sings most notes accurately varying tempo when time is needed to think about the pitch.	Student beginning to sing some proper notes and varies tempo when time is needed to think about the pitch.
2. Intonation	Student sings all notes in the center of the pitch.	Student sings most of the notes in the center of the pitch.	Student sings several notes flat or sharp but can correct them with assistance.	Student sings most of the notes flat or sharp but is beginning to recognize that pitches are incorrect and can correct some of them.

Other criteria can include rhythmic accuracy, diction, vowel placement, ensemble precision, appropriate dynamic level, tone quality, phrasing and breath management, balance, blend, and interpretation, which are listed down the left side of the rubric. Because they are numbered, you can select the criteria numbers you would like to use for each assessment. For instance, on one vocal evaluation, you may want to assess breath management and intonation. Another time, you may want to assess diction or balance.

When writing statements for the rubric for Levels 4, 3, 2, and 1, start by writing the Level 3 statement. This is the level the majority of students ideally should be at and is considered grade level. Level 4 is the exceptional edge, which shows ease of execution, creativity, or

musical finesse. Level 2 is a developing stage in which progress toward the goal of Level 3 is visible. Level 1 includes the beginning stages of development. Never use Levels 1 and 2 to punish a student or make him or her feel unsuccessful. These are only stages to show the student's growth toward a goal.

Always let students know exactly what is going to be assessed; give them the rubric ahead of time, so they know how to prepare and are successful. This success breeds a desire to do one's best, eliminating discipline problems and encouraging musical independence.

A teacher's biggest battle is deciding how to organize the scores for easy documentation. Learn a spreadsheet program so that you can put the criteria at the top and drop in the names of the students on the left. Keep a copy of this scoring sheet in a binder, so it is quickly and easily accessible.

Consider an evaluation sheet for each student that lists scores by standard (performance scores from the rubric show the student what is going well and what still needs work):

1. Proper posture and playing position (instrumental) checklist

2. Improvisation scores

3. Composition and arranging scores

4. Theory scores

5. Listening, analyzing, and describing scores

6. Evaluating music and music performance scores

7. Scores from activities on understanding music in relation to other arts and disciplines

8. Sores from activities understanding the relationship between music and history and culture

9. Tuning procedures scores

10. Written tests or exercises scores

Rubric scores occasionally have to be converted to a letter grade, and this can be accomplished by "weighting" some criteria heavier than

others. For example, on a playing test, you may want to weight tone times three, intonation times five, and rhythm times three; then, include a total score that you can use to calculate percentages for letter grades. Some school prepackaged grading programs allow you to weight components of a grade as well. If you prefer to weight performance assessments higher than written work, the option is available to each individual teacher.

If assigning letter grades from rubric scores, one possibility may be Level 4 as an A+, Level 3 as an A, Level 2 as a B, and Level 1 as a C.

I can't stress enough the importance of developing a fine standards-based curriculum in conjunction with assessments. Sequencing materials allows students to follow the chronological manner in which you build upon concepts while practicing previously learned concepts. It also shows your administration that you are a teacher current in educational philosophies, which may prevent art programs or teachers from being cut. Most important, the students become engaged, enthusiastic, lifelong learners, and learning is a partnership with the students.

▧ 38. Comics: Integrating Language Arts, Math, and Social Studies With Art

Amy K. Dean
Fort Mill, South Carolina

Recommended Level: Grade 8

Overall Objective: Students will understand that comics are a visual language that communicates ideas, tells stories, and evokes emotional responses in the viewer. They will be able to create their own comic strip.

Standards Met (South Carolina):

Art: (4.B) Compare and contrast a variety of artworks, artists, and visual arts materials that exist in South Carolina; (6.B) Compare and contrast concepts and subject matter found in the visual arts with those in other disciplines; (6.C) Identify visual arts careers and the knowledge and skills required for specific art careers.

Language Arts: (6–1.4) Analyze an author's development of characters, setting, and conflict in a given literary text.

Math: (8–4.3) Apply a dilation to a square, rectangle, or right triangle in a coordinate plane; (8–5.6) Analyze a variety of measurement situations to determine the necessary level of accuracy and precision.

Social Studies: (8–7) The student will demonstrate an understanding of South Carolina's economic revitalization during World War II and the latter twentieth century.

Materials Needed:

- White drawing paper, 12 × 18 inches
- Sketchbook
- Colored pencils
- Pencils
- Markers
- Crayons
- Computer presentation on comic history (found online or compiled from information in print sources)
- Comics by Doug Marlette (n.d.)
- *Doug Marlette 2000,* by Doug Marlette (2001b)
- Students' samples
- Comic strips from local newspapers

This unit is part of a larger unit that includes the study of various artists and art forms from the South Carolina region and America. Students are taught the history of comics, techniques in creating an effective comic, and facts about local comic artist Doug Marlette.

Day 1

Introduction

1. Students will complete a preassessment describing what they know about comics and Doug Marlette (or another popular comic artist).

2. Pass out comics from the Sunday paper and tell students to list characteristics of them. Describe the colors and other elements

of design used as well as anything they notice about the story (the purpose, target audience, etc.).

3. Ask students to share their observations and discuss as a class.

4. List observations on the board, and circle features you would like students to remember, such as the use of separate frames for each scene.

Lesson

View and discuss a computer presentation on the history of comics and superheroes (how comics began, changes over decades, and how they were influenced by important events such as World War II).

There are a number of possible discussion points:

a. How and why sequential art has been used over time (as language in hieroglyphs, as entertainment, etc.)
b. The nature and content of the first comics and their purpose.
c. The introduction of female superheroes, how such heroines were characterized, and how their presence affected comic book readership.
d. The current content and style of comics and graphic novels, and how they differ from earlier comics.

Closure

Tell students they will be creating their own comic and should start thinking about a superhero and plot.

Days 2 and 3

Introduction

1. Ask students to remind you of things they noticed yesterday about comics.

2. List important qualities of comics that students will be required to have in their comic strips. Show examples of student work.

Lesson

Comics should include the following:

a. Separate frames. First frame should have a title and artist's name. This may also include their first scene.
b. Black outlines. Outline around objects and frames.
c. Plot. Include conflict and resolution.
d. Setting. Dilate some scenes to add interest and change viewpoints; for example, create close-ups and panoramic views.
e. Characters. Incorporate a superhero, victim, and villain: These can be as complex as the student's ability to draw. For example, their story can be about a fruit war or can be about a complex stereotypical muscle-bound superhero.
f. Show action. Explain to students that in order to show action in a figure they must draw their body parts in a diagonal direction. If everything is drawn horizontally or vertically, pictures won't look like they are moving. For example, by simply drawing one leg at an angle, the figure will appear to be walking.
g. Expressions. Draw a chart as a class for students to copy in sketchbooks as a reference to show a variety of possible expressions. This should include eyebrows and mouths.

Closure

1. Remind students to make sure they have all of the requirements for comics in their sketchbooks.

2. Tell them to start sketching their ideas for a comic, including everything taught the past two days.

Days 4 and 5

Introduction

1. Ask students to list the project requirements. Clarify anything missing.

2. Ask students to explain how to show figures in action.

Lesson

1. Instruct students to sketch at least five frames, including their title frame, in order to tell a complete story. Tell them they will probably spend the next two to three days sketching their ideas.

2. When students are finished with their sketches, have them share their work with another student to check whether their comic makes sense. Encourage students not to tell the reader anything about their comic in advance, so they can find out on their own whether anything is unclear. If something is confusing, the reader should discuss it with the artist.

3. Students correct comics after a peer review, and then the teacher determines whether they are ready for their final copy paper.

Closure

Tell students they should not begin drawing until they are told how to divide up their paper evenly.

Day 6

Introduction

Tell students they should be ready to start drawing their final copy and they should use rulers to measure their frames.

Lesson

1. Show students how to divide paper into equal sections using a ruler to ensure their boxes aren't too far apart and empty space isn't left at the end of their comic.

2. Explain that if they have an odd number of frames, they might want to double the size of one of their frames to make it easier to measure.

3. Select students to pass out rulers.

4. Students will begin dividing their paper into equal sections to determine where to draw frames.

Closure

1. Select students to collect rulers.

2. Remind students that once they have their boxes drawn they may begin drawing their comic strip.

Days 7 and 9

Introduction

Remind students they can begin drawing comics once their frames have been drawn.

Lesson

1. Tell students not to color their comics until they are instructed how to do so.

2. Students will draw comic strips.

Closure

Clean up drawing materials and put away artwork.

Days 10 and 12

Introduction

Tell students they will be learning about coloring options today.

Lesson

1. Show students images of a printing press, and discuss how it works.

2. Tell students that typically only red (or magenta), blue (or cyan), yellow, and black are used to create the variety of colors seen in

comic strips. However, you will allow them to use all of the colors available to them.

3. Tell students that in order to show a variety of values in a black-and-white comic they must use shading techniques, such as stippling, hatching, and crosshatching.

4. Define "value" as the lightness or darkness of a color.

5. Demonstrate how to do stippling, hatching, and crosshatching.

6. Tell students that if they choose to do their comics in black and white, they must use at least one of the shading techniques.

7. Tell students they can use markers, crayons, and colored pencils to color in their comic.

8. Students will begin coloring their comics.

Closure

1. Review colors used in the printing press and shading techniques.

2. Clean up.

Day 13

Introduction

Show students a comic strip print by Doug Marlette, and tell them they will learn about his life.

Lesson

1. Show a variety of examples of Doug Marlette's work and his photo while discussing his life: He was born in Greensboro, North Carolina, and began drawing comics for the *Charlotte Observer* in 1972. His editorial cartoons and comic strip, *Kudzu,* are syndicated in newspapers worldwide. He has won every major award for editorial cartooning, including a 1988 Pulitzer Prize, and was awarded a Neiman Fellowship at Harvard University.

He has also written books, such as *The Bridge* (2001a), of which film rights were bought by Tom Cruise and Paramount. (Doug Marlette, n.d.)

2. Assessment: Tell students to look at one of Marlette's (n.d.) *Kudzu* comics and describe the characteristics they were required to use in their own comics. They should list every characteristic and be specific about which frame they found each one in. For example, "In scene three, the dog *shows action* by leaning against the tree."

Closure

1. Students turn in postassessment assignment as well as finished comics for a grade. You may also test them on knowledge of Marlette.

2. Display comics to be viewed by peers and faculty. If you have a school paper, submit them for possible publication.

Modifications

Elementary Students	• Eliminate lessons such as the history of comics. • Reduce the amount of information taught and required; for example, include only four of the seven requirements for drawing the comics.
High School Students and Students in Gifted and Talented Programs	• Require students to draw human superhero figures and include call-outs, logos, and dialogue. • Teach supplemental information about the history of comics and Doug Marlette's life. Look at how science and other advances in American society have influenced themes and artwork.
Students With Learning Disabilities and Handicaps	• Copy learning buddy's notes. • Encourage students to draw simple shapes for characters, such as a moon or sun.
Other Possibilities	• Compare and contrast comic artists. • Take a field trip to the local newspaper to talk to comic artists and see a printing press. • Discuss pop artist Roy Lichtenstein and the influence of comics on his art.

References

Doug Marlette. (n.d.). Retrieved from http://dougmarlette.com/index.html
Marlette, D. (2001a). *The bridge.* New York: HarperCollins.
Marlette, D. (2001b). *Doug Marlette 2000.* Melville, NY: Newsday.

ℕ 39. Edible Color Wheels: A New Way to Introduce Color Theory

Gayle Gruber Hegerich
Brick, New Jersey

Recommended Level: Grade 6

Overall Objective: Students learn the basics of mixing the primary, secondary, and intermediate colors through this fun hands-on activity.

Standards Met:

National

> *Visual Arts:* (1) Understanding and applying media, techniques, and processes; (2) Using knowledge of structures and functions; (3) Choosing and evaluating a range of subject matter, symbols, and ideas; (4) Understanding the visual arts in relation to history and cultures; (5) Reflecting upon and assessing the characteristics and merits of their work and the work of others; (6) Making connections between visual arts and other disciplines.

New Jersey

> *Visual Arts:* (1.1) *Aesthetics:* All students will use aesthetic knowledge in the creation of and in response to dance, music, theater, and visual art; (1.2) *Creation and Performance:* All students will use those skills, media, methods, and technologies appropriate to each art form in the creation, performance, and presentation of dance, music, theater, and visual art; (1.3) *Elements and Principles of the Arts:* All students will demonstrate an understanding of the elements and principles of dance, music, theater,

and visual art; (1.4) *Critique:* All students will develop, apply, and reflect upon knowledge of the process of critique; (1.5) *History/Culture:* All students will understand and analyze the role, development, and continuing influence of the arts in relation to world cultures, history, and society.

Materials:

- Color wheels
- Vanilla icing
- Food coloring
- Vanilla wafers
- Plastic knives
- Paper plates
- Handouts on color theory

Students will be able to

- understand primary, secondary, and intermediate colors;
- identify how colors are mixed and obtained (two primaries equal a secondary, and one secondary and a primary make an intermediate color);
- work with all tools safely and properly;
- work in teams successfully;
- create all 12 colors of the color wheel; and
- understand the importance of color in the history of art.

Students have fun while exploring the world of color. Many times I find students, after we've completed our unit on color theory, ask, "How do I make purple paint?" While I have always done an extensive unit on color, I felt the need to add an engaging activity that would help my sixth-graders grasp the basic tenants of color theory. Edible color wheels help children remember how to mix paint. Before beginning my unit, I open with the Edible Color Wheel project. For safety, I begin by asking whether any of the students has any food allergies. If anyone does, I have him or her work on a color wheel packet.

Class begins with a basic introduction to color theory. I review the primary, secondary, and intermediate colors. We discuss analogous and complementary colors. I ask my students whether they know how to make purple, orange, and green paint. After reviewing

color mixing, I introduce our special project: Edible Color Wheels. This is a team-building project based on color theory. I break my class into teams of four. Each team is responsible for working together to replicate the 12 colors of the color wheel using vanilla wafers, food coloring, and vanilla icing. To make it even more interesting, I give out prizes to the team that replicates the colors most accurately.

Each team receives 13 wafers: one for the grey in the middle and 12 for the colors of the wheel. Each team also receives 13 small scoops of vanilla icing on a plate. Students carefully use the food coloring to mix the colors. Once the 13 colors are made, the teams ice their wafers and place them in the proper order for display. I judge their work, award prizes, and then the students eat their team's wheels.

HelpfulTips

Make sure your students don't have any food allergies. Also, be sure your students wash their hands before and after the completion of the project. The students get very excited and can complete the project in 45 minutes. Plastic knives and disposable plates ensure a quicker cleanup, which is especially important if you have another group of students coming.

40. Chinese Zodiac: What Animal Are You?

Gayle Gruber Hegerich
Brick, New Jersey

Recommended Level: Grade 7

Overall Objective: Explore the ancient world of the Chinese zodiac as students create unique pieces based on their year of birth. Students learn about the ancient folktale of how the 12 animals of the zodiac were selected and how the Chinese zodiac differs from the astrological calendar used in the West.

Standards Met:

National

> *Visual Arts:* (1) Understanding and applying media, techniques, and processes; (2) Using knowledge of structures and functions; (3) Choosing and evaluating a range of subject matter, symbols, and ideas; (4) Understanding the visual arts in relation to history and cultures; (5) Reflecting upon and assessing the characteristics and merits of their work and the work of others; (6) Making connections between visual arts and other disciplines.

New Jersey

> *Visual Arts:* (1.1) *Aesthetics:* All students will use aesthetic knowledge in the creation of and in response to dance, music, theater, and visual art; (1.2) *Creation and Performance:* All students will use those skills, media, methods, and technologies appropriate to each art form in the creation, performance, and presentation of dance, music, theater, and visual art.; (1.3) *Elements and Principles of the Arts:* All students will demonstrate an understanding of the elements and principles of dance, music, theater, and visual art; (1.4) *Critique:* All students will develop, apply, and reflect upon knowledge of the process of critique; (1.5) *History/Culture:* All students will understand and analyze the role, development, and continuing influence of the arts in relation to world cultures, history, and society.

Materials Needed:

- White drawing paper
- Colored pencils
- Pencils
- Black waterproof markers
- Construction paper

- Handouts on the Chinese zodiac, including the folktale describing the origin of the Chinese zodiac (can be found online)

Students will be able to

- understand the background story of the ancient folktale of the formation of the zodiac and the choosing of the 12 animals of the zodiac;

- identify which zodiac animal they are, based on their year of birth;
- work to create a unique illustration for their zodiac animal;
- use color pencils to create subtle shading and tonal differences;
- work with color, line, and shape; and
- create a successful composition that includes the animal symbol.

Students, especially middle school students, love projects directly related to them. Through this lesson, students create a unique illustration for their animal of the Chinese zodiac based on their year of birth. Class begins with an introduction to the Chinese zodiac. Then, the class reads the folktale of how the 12 animals were chosen, and we discuss the differences between our use of astrological signs by month of birth and the Chinese zodiac by year of birth. We also discuss the personality characteristics associated with the animals.

The students are then shown samples of a variety of different artists' illustrations of the 12 animals. Students are told what animal they are based on. While most students pick the animal associated with their year of birth, some choose to illustrate another animal. Students spend some time sketching, paying careful attention to the look they are trying to create, that is, cartoon style or realistic. Once the students have their composition blocked out, they add in the Chinese character for their animal. Students work with colored pencils to shade their animal and black markers for the character; then, they glue their illustrations onto a large piece of construction paper to serve as a quick and easy frame.

HelpfulTip

Discuss the personality characteristics associated with the zodiac animals. It is fun to hear students talk about whether or not they are like the animal signs.

Physical Education

Overview, Chapters 41–42

41. **Kathleen F. Engle**, a physical education teacher with 27 years of experience from Newcastle, Wyoming, recommends a variety of activities and stretches appropriate for sixth- to eighth-graders. Kathleen recommends having students lead the warm-up exercises to help them gain valuable leadership skills.

42. **Erin Sweeney,** a health and physical education teacher from Gainesville, Virginia, has great suggestions for team-building exercises. Your class will enjoy going through the spider web and untangling the human knot in small groups or large ones. Be sure to check out the helpful tips as well as the suggestions for incorporating a journaling exercise into these activities.

▨ 41. Feel It Today: Warm-Up and Conditioning Routine

Kathleen F. Engle
Newcastle, Wyoming

Recommended Level: Grades 6–8

Overall Objective: Students will increase their strength and endurance in the components of fitness by participating in a rigorous warm-up routine on a daily basis.

Standards Met (Wyoming):

> *Fitness Literacy:* (2.1) Students explain and assess their personal fitness status in terms of cardiovascular endurance, muscular strength and endurance, flexibility, and body composition; (2.2) Applying principles of fitness (FITT, warm-up and cooldown, progression,

and overload), students select and describe lifetime physical activities that enhance health-related fitness; (2.3) Students create personal fitness goals; (2.4) Students recognize and explain valid characteristics of products and technology related to fitness literacy; (2.5) Students participate in a variety of physical activities that will enhance health-related physical fitness.

Materials Needed:

- Large poster board on which the routine is typed
- Whiteboard or wireless interactive whiteboard (such as a SMART board notebook) technology makes it very easy to change the exercises.
- Large area or gym in which to do the warm-up

I use this simple and effective routine daily to increase each student's personal achievement in the components of fitness: cardiovascular endurance, muscle endurance, muscle strength, and flexibility. I also include other principles of fitness such as FITT (frequency, intensity, time, and type of exercise), overload, warm-up, and cooldown.

Students form two lines on the outermost area of the gym close to the wall. They are a good arm's length apart and face the center of the gym. Students take turns leading the warm-ups, which are posted on the whiteboard. When students lead the warm-ups, they learn to take control of situations. In essence, my students become teachers and earn points for good modeling and for their ability to get others to follow their command. On the leader's command, the students begin moving toward the center of the gym performing the list of developmentally appropriate dynamic stretches on the posters or whiteboard. There are a multitude of dynamic stretches that can be used for total-body fitness. Most often, I use exercises to get my students' large muscle groups and cardiovascular systems warmed up and ready for activity. These include walking high kicks, high knee–pull to chest, bottom kickers, Russian march, grapevine or karaoke, high skip, dynamic hurdle, side shuffle, side-to-side bound, jail man, tiny jumps, squat jump (watch landings), inch worm, and lunges.

I have the students perform the exercises moving forward to the center line, and then the students do the same movement backward to the end line. This allows my students to develop balance throughout the

movements. Those exercises that are not performed forward and backward are completed from right to left. The strategies of working students forward and backward and side to side provide students with agility and balance development on a daily basis. This routine is very rigorous and demands a great deal of effort on the part of my students. Once the students have completed the dynamic stretches to warm up their large-muscle groups, as well as to increase their cardiovascular capacity, they return to their squads.

I now have the students continue their warm-up by working on their strength and endurance. These exercises are completed on the floor using the weight of their own body. Each exercise is designed to place resistance on the muscles and bones that students have warmed up in the dynamic stretches. Each exercise is held for 30 seconds with the overall goal to get to one minute by the end of the year. Many students set individual goals past the minute mark. My students' favorite resistance exercises are push-ups, crunches, V-sit, front plank, side plank, back plank, tripod plank (students lift a body part off the floor leaving only one hand and two feet on the floor to balance, etc.), and the superman or superwoman hold.

The resistance training allows a young adolescent's body to build bone density and increase endurance. I often challenge students to hold the exercise longer. I talk to my students about the importance of warming up and cooling down, overloading the muscles, and the FITT principles of frequency, intensity, time, and type of exercise. Students learn the importance of increasing the frequency and intensity of these exercises over time to help them become stronger. They learn the value of time in exercise when they are challenged to hold a position or jog longer and how this duration increases their overall ability to be stronger. They can "feel it today."

I let my students know they have to work past what is comfortable to build strength and endurance. I am very honest about letting my students know that they may feel miserable and even nauseated if they have pushed their bodies past their comfort zone. I believe that it is important to let students know working physically does hurt and they may feel discomfort and that this feeling is okay. I have the students finish the warm-up by doing a variety of static stretches. The favorite is the wall sit, although it is not the original wall sit. My students call this "ouch stretch." Students sit with their gluteals as close to the wall as possible, their backs on the wall, shoulders pressed against the wall, and

heads up. They bring their legs close together with toes pointed straight to the ceiling. If the students do the stretch correctly, this position attacks the hamstring muscles, the muscles in the soles of the feet, the gastrocnemius muscles, and the Achilles tendons. When students feel the stretch, I have them begin to breathe deeply and relax into the stretch and then take another deep breath and relax into the stretch again. This is the most amazing stretch, because over time it allows my students to develop the flexibility needed to increase their sit and reach assessment scores. More important, it decreases injuries to the leg muscles and tendons, especially the Achilles tendon. Students may complain that growth spurts strain this area of the body. I tell my students if they are not using great posture while sitting against the wall, the stretch will not be effective.

The final task my students complete in this warm-up is to increase their cardiovascular endurance through a variety of locomotor skills. My students jog, skip, gallop, hop, and jump rope for approximately four minutes. Then, they walk two laps for a cooldown, get drinks, and we begin the day's lesson. This warm-up should take about 12 minutes to complete. I hope many physical education teachers and even coaches find this warm-up to be a useful tool. It truly is the best practice I have found that contributes directly to the personal achievement of my students. My students also come to realize that there are so many options available with this type of warm-up. I change exercises and routines depending on what type of activity the students will be doing that day in physical education. If I change the exercises to complement my lesson, the workout remains a rigorous task to complete.

All of my classes are inclusive, and this lesson is perfect for all abilities as it is individually paced. My students with special needs excel in this warm-up because they are able to work at their own pace. This warm-up allows me to modify on the spot. If a student cannot complete a given exercise for the required count or amount of time, then they can do whatever their ability allows them to. The same goes for my students in regular education; if they can complete a given exercise for a count of 20 instead of 10, then they are encouraged to do so as long as they are still using the correct body position. You can see how much they like the structured, consistent routine.

I constantly strive to find ways to assess student performance. Assessing in the physical world can become very objective as I often use performance (skill checklist) as criteria for my students' completion of

tasks. This warm-up makes it very easy to set expectations and criteria (e.g., holding the plank for a longer period of time or decreasing their time in cardiovascular development) for students to work toward while increasing personal fitness. This warm-up allows my students to experience real-life challenges when learning what it takes to stay fit for a lifetime. I use authentic assessments to pre- and posttest each student in their level of fitness using the sit and reach for flexibility; the three-minute step test and the mile for cardiovascular endurance; and push-ups, sit-ups, and the plank for muscular strength and endurance. Students are not only able to feel they are improving, but they are able to see the improvement in their level of fitness as their numbers increase or decrease as revealed in the assessments. I am able to provide feedback and refinement on a daily basis.

Helpful Tips

- You can help other teachers implement your ideas by including ways to adapt the material for different grade levels or populations of students. As a physical educator, I have a responsibility to provide my students with the best opportunity to be physically fit for a lifetime. This daily warm-up evolved because of the overall poor physical condition of our middle school students. This simple and effective routine requires that students set individual goals for their fitness level. The consistency and structure expected on a daily basis allows students to truly feel the increase in the strength and endurance of their body. As time passes, I see the pride and joy my students experience when they realize they are feeling the fruits of their labor. This routine is rigorous and demands students' commitment to working their bodies hard and going beyond what is comfortable. I let them know that doing these exercises with vigor is what will allow their bones and muscles to grow and become stronger. It is not an easy sell, but soon the students begin to buy in as they begin to feel the changes in their ability to do a variety of cardiovascular endurance, strength, and flexibility activities.

■ My "teacher tidbit," after 27 years of losing many minutes of class time on finding students' gym clothes, is this: I would like to urge all of my colleagues in this profession to consider ordering student uniforms. I did this last year for our department, and there is a positive change in my effectiveness as a teacher. The initial time you will spend ordering, writing names on shorts and shirts, and distributing the uniforms will be made up for in the time not spent on all other issues of clothing. I have 100% of my students dressed out every day. If an article of clothing is left out, I can instantly return it to its owner as student names are on the shorts and shirts. Students love it as they do not have to worry about someone stealing their brand-name clothing. I love it as the shorts are long enough and shirts are large enough so that students can do all class requirements without having body parts showing. Students were a little apprehensive at first, especially our high school conditioning class, because they wanted to wear muscle shirts. Once I explained that muscle shirts will not be allowed because they are not school appropriate, the students were sold. Parents love this idea as they only need to purchase one uniform for their child's middle school years for the price of $20. I can assure you that this simple idea will change your class climate in a very positive way.

42. Spider Web and Human Knot

Erin Sweeney
Gainesville, Virginia

Recommended Level: Grade 8

Overall Objective: Students will be able to solve challenging tasks while working together as a group.

Standards Met (National):

Physical Education: (2) Demonstrates understanding of movement concepts, principles, strategies, and tactics as they apply to the learning and performance of physical activities; (3) Participates regularly in physical activity; (5) Exhibits responsible personal and social behavior that respects self and others in physical activity settings; (6) Values physical activity for health, enjoyment, challenge, self-expression, and/or social interaction.

Materials Needed:

- Posted Human Knot and Spider Web instructions (Usually I do this on our whiteboard.)
- Two spider webs made out of volleyball standard poles and clothesline

- Eight safety mats
- Copies of journal-entry sheets with writing utensils (See the sample journal-entry form at the end of this activity.)

During the set-up process, I visually split the gym in half, and on the left side of the gym, I post the following instructions for the human knot activity:

Your group will form a small circle. Everyone will reach out with their right hand and grab someone's hand across from you. Everyone will reach out with their left hand and grab a different person's left hand. Without letting go, you will untangle yourselves to form a perfect circle.

On the right side of the gym, I post the following instructions for the spider web activity:

Using only the holes in the web, your group will cross to the other side. Once a hole is used, that hole is closed off and no one else may travel through it. If you touch the rope or poles at anytime during the activity, the entire group must start over.

There is no equipment needed for the Human Knot. There are spider webs available for purchase through PE equipment companies; however, I make my own using volleyball standard poles and clothesline. I just wrap the clothesline around the poles, going from one pole to another, and crisscross the lines so that there are holes available all throughout the web. I make two webs and space them far enough apart to give each group room for their activity. I also place safety mats under the webs. The only other preparation is to have journal-entry sheets available.

I start the lesson by explaining that the focus is solving tasks as a group. I explain each activity without a demonstration, so the students have to figure out how to accomplish the tasks on their own. You must review safety for the spider web activity. Students have to communicate and work together if they decide to lift someone into the air, and the head must be protected at all times. If the students cannot perform this activity safely, bring the activity to a halt and review safety or eliminate the activity altogether. Divide the class into four groups, and send two groups to Human Knot and two groups to Spider Web. The students will then be given class time to work on their challenge. I usually allow about 15 minutes depending on how well the groups work together to solve the task. If you have more time, such as a block class, then you could switch the groups after 15 minutes so everyone has a chance at each activity. I usually have the students switch tasks the next class due to time.

You will then need 10 minutes to reflect at the end of the period. Ask your students, "Why were the groups who accomplished the Human Knot or Spider Web successful?" You should receive answers such as "They communicated with each other," "They worked together as a team," and "They thought things out before trying." Ask the students how they can take what they learned and apply it to other aspects of life. Activities like this will help them later on in life. Then, hand out the journal-entry forms. I usually start out their sentences for them, and they can then pick up and write their entry from there. "During the Human Knot (or Spider Web), I felt like I did (or didn't) help my group because . . ." The requirement for how much they are to write is left up to you. Reflection is an essential part of adventure education, so please leave room at the end of class for them to have plenty of time to discuss or write about the activity.

Helpful Tips

- For the Spider Web
 - ❖ To make the activity easier or to help include a person with disabilities (such as an individual in a wheelchair), make a wide space from the floor to the first part of the web and make that an available hole for someone.
 - ❖ Make sure the rest of the holes are big enough for students to pass through so that they have a chance to be successful.

- For the Human Knot
 - ❖ If your students have issues holding each other's hands, provide objects like scarves or bandanas for the students to hold onto instead.
 - ❖ If students are struggling with the activity, you can break up the groups into smaller numbers. If they find this easy, add more people to their group.

Sample Journal-Entry Form

Name _____ Date _____

Describe how you felt you did today during _____.

Make sure you write your feelings using complete sentences in paragraph form.
